LEGENDARY LOCALS

— OF —

CONCORD

NEW HAMPSHIRE

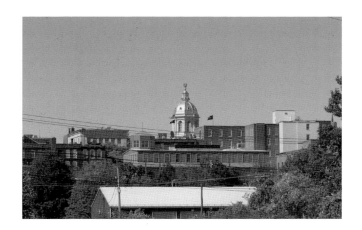

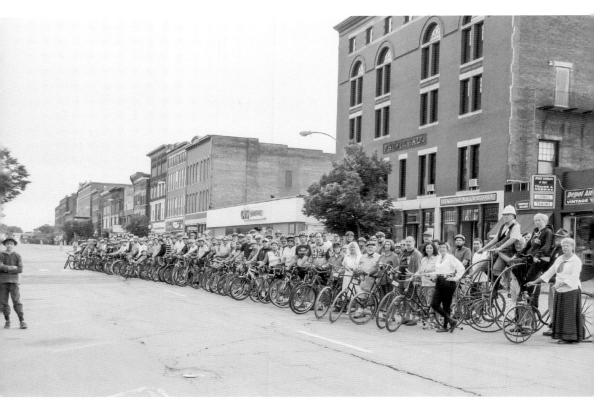

Bicycles 2014
In the late 1890s, a group of bicyclists gathered for a photograph. Not much is known about why they lined up on North Main Street. Then, 125 years later, the idea to recreate that photograph was inspired by this group of riders and their bicycles. In keeping with the 1890s photograph, riders lined up on North Main Street once again one early Sunday morning in July 2014, capturing the changes that have occurred to the buildings, bicycles, and riding attire over the past 100 years. (Courtesy Rich Woodfin.)

Page 1: Concord Skyline and State Capitol Dome
The capitol building is largely made up of granite blocks quarried from a local site. Stuart J. Park designed the building in 1814 with a 150-foot gold dome, but construction did not begin until 1816, taking three years to complete. Over the years, the building has been enlarged, and extensive renovations were done throughout to modernize it. In 1909, electric lighting, heating, and a third floor were added. (Photograph by author.)

LEGENDARY LOCALS
OF

CONCORD
NEW HAMPSHIRE

LORRAINE A. COURTNEY

Legendary Locals is an imprint of Arcadia Publishing
Charleston, South Carolina

Printed in the United States of America

Library of Congress Control Number: 2014948878

For all general information, please contact Arcadia Publishing:
Telephone 843-853-2070
Fax 843-853-0044
E-mail sales@arcadiapublishing.com
For customer service and orders:
Toll-Free 1-888-313-2665

Visit us on the Internet at www.arcadiapublishing.com

Dedication
To my sister, Fran, whose guiding light helped illuminate the path I would take in life

On the Front Cover: Clockwise from top left:
John Winant, governor (Courtesy Library of Congress; see page 80), Marilyn Nylen, businesswoman
(Courtesy Marilyn Nylen; see page 10), Edward Brooks, World War II hero (Courtesy Library of
Congress; see page 51), Michael Hermann, independent bookstore owner (Photograph by author; see
page 26), Alice Cosgrove, painter (Courtesy Milne Special Collections; see page 101), Hannah Dustin,
early settler (Photograph by author; see page 92), Sandy Shafer (Photograph by author; see page 119),
Douglas Black, obstetrician (Photograph by author; see page 19), Daniel Courtney, band member
(Photograph by author; see page 49).

On the Back Cover: From left to right:
Laura Knoy, radio host (Courtesy New Hampshire Public Radio; see page 75), Gen Woodward, dance
instructor (Photograph by author; see page 20).

CONTENTS

ACKNOWLEDGMENTS

I gratefully acknowledge Mary Louise Hancock and Milne Special Collections at the University of New Hampshire for information and photographs of Alice Cosgrove.

Many thanks to the Longyear Museum, Chestnut Hill, Massachusetts, and to Constance Shryack, the resident overseer at the Mary Baker Eddy House in Concord, for the invaluable information and photographs of Eddy's life.

I sincerely appreciate the time I was given to sift through countless photographs of Paul Giles and the Giles family. There is a rich history behind the Nevers' Band, and I was glad to have the opportunity to learn more about this musical family from Deborah Giles Lincoln.

I am grateful for the information I was given by Peter and Vera James of the Abbot-Downing Museum, who keep the important history of the Concord Coach alive.

Many thanks to Dave Anderson, director of education and volunteer services at the Society for the Protection of New Hampshire Forests.

Special thanks to Peter G. Cline, Esq., for his assistance and organizational support.

Thank you to my family, friends, and colleagues for their enthusiastic support throughout the project.

Unless otherwise noted, all images appear courtesy of the author. The abbreviation LOC designates images courtesy of the Library of Congress.

INTRODUCTION

Once an agricultural community, Concord was a hotbed of manufacturing and inventions during the 1800s. Everything from stagecoaches to pianos and bricks to machinery was made in Concord. John A. White manufactured mechanical machines. The Abbot & Downing Company produced nearly 2,000 stagecoaches of all sizes, some capable of carrying 15 to 20 passengers to faraway places. The stagecoach thus expanded the transportation system in New Hampshire and beyond. Prescott Pianos were produced right on South Main Street. A visitor can see one on display in the Mary Baker Eddy house on North State Street.

While Concord continued to grow and expand into a transportation hub, the remains of its agricultural roots are within city limits. A stabilizing force in the community is Murray's Farm Greenhouse, a family-owned business for more than 100 years run by Helen Murray.

Concord's name comes from the Latin for "with heart," and it means "harmony." Gov. Benning Wentworth knew this when he changed the name from Rumford to Concord in 1765 during a land dispute between Bow and Concord. Indeed, Concord has a lot of heart. The population of approximately 43,000 citizens is becoming more diverse each year. Concord exhibits strong economic growth, a healthy political climate, and robust business development, but it would not be as strong a community without the helping hands of a legion of volunteers. Many citizens and nonprofit organizations have worked diligently to provide to those in need. The Friendly Kitchen has served thousands of hot meals to the homeless since 1980. People like Marilyn Nylen, Jeremy Woodward, and the staff at Wesley United Methodist Church devote hours to serving and fundraising for noteworthy organizations.

The historical figures included here, like Franklin Pierce and Barbara Webber, have made contributions to Concord in more than one way over their lifetimes. These citizens have influenced its life, culture, and environment in a profound way.

Many organizations continue to work at making Concord a livable city. The Society for the Protection of New Hampshire Forests has many trails and woodlands set aside for citizens to enjoy. The City of Concord maintains over 30 different hiking trails within its 67 square miles. History is fascinating, and so are the choices people made in the past in particular circumstances. Throughout history, choices are made that fall within the life-altering and community-building categories. Whether due to compelling reasons or just poor judgment, people's choices become their history in hindsight.

Examples of choices that these legendary locals had to make are all around: a new piece of legislation is signed into law or vetoed; an entirely new religion is begun, based on science and faith in a time when women had no rights; a land dispute is settled once and for all that gives birth to a new city.

It is hoped that this book will inspire readers to look deeply into Concord history. At this juncture, the 250th anniversary of Concord, residents should pay special attention to how the past can shape the future.

For all of its people, Concord is a place of new beginnings where people can live in harmony and enjoy the fruits of their labor. People who live here know, and those who move here soon find out, that Concord is a great place to live and work.

—Lorraine Courtney
September 2014

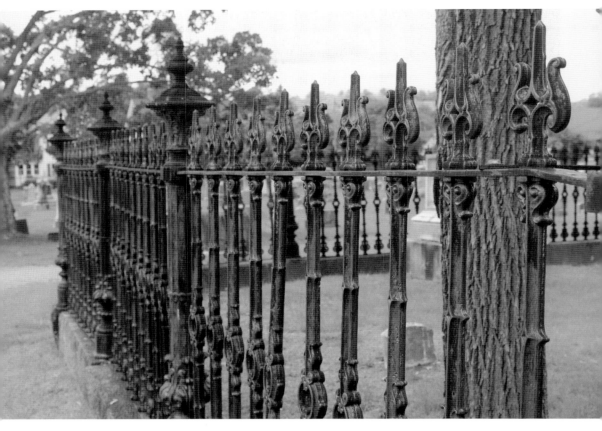

Minot Enclosure, Old North Cemetery
Many of Concord's prominent citizens are interred within these gates of the Minot Enclosure of the Old North Cemetery, the first burial ground established in Concord, in 1730. Franklin Pierce and his family, Lewis Downing and his family, and the Minot family have all been laid to rest here.

CHAPTER ONE

Health

This chapter highlights the people, past and present, connected to the maintenance or improvement of healthy living. Concord has its share of health stores, fitness outlets, health professionals, and nonprofits dedicated to promoting a healthy lifestyle. In addition, the city offers many green spaces for residents to enjoy the outdoors. There are 11 parks spanning more than 323 acres, seven pools, a couple of city forests, a municipal golf course, and over 1,000 acres of hiking trails, with new ones being established every year.

Readers will learn about people like Jeremy Woodward, who, after two open-heart surgeries, committed himself to a healthy lifestyle and helps others achieve the same. Nurses from years past, like Harriet P. Dame, volunteered to go into battle and devoted themselves to helping wounded soldiers. Eva May Crosby, in the early 1900s, improved the nursing profession and patient stays at hospitals.

But this chapter would not be complete without including people like Dr. Douglas Black, an obstetrician who came to Concord in 1963 and never left. He helped raise five children and delivered babies at the hospital. Although retired from medicine, he is still actively involved in Concord's wellness. He is a city treasure, warm and charismatic, full of information and stories about Concord's past. Harris Berman graduated from Concord High School (CHS) and is recognized as a pioneer in managed-care delivery systems. These people help make up the fabric of the community. By engaging in a healthy lifestyle, people live longer and have a higher quality of life. What better place to do it than in Concord?

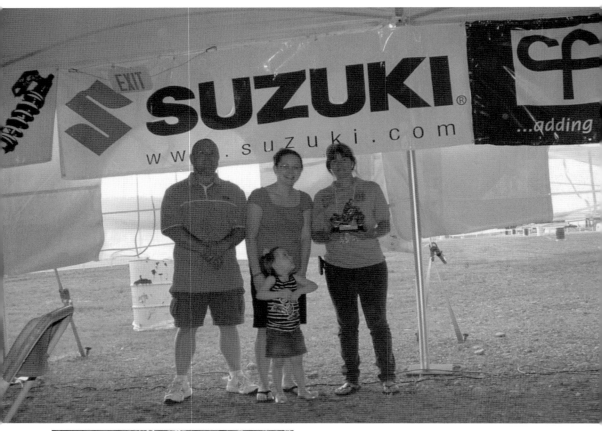

Marilyn Nylen, Business Owner, Volunteer

Nylen built her business, Akasha Massage and Bodywork, on a shoestring budget. At one point 20 years ago, she was not sure where she was headed with her career, so she started to look at job possibilities. Upon graduation from massage school, with no clients of her own, Nylen found a mentor who helped her attract clients, and she slowly built her business.

As word traveled, her business grew. Now, Nylen, an avid runner, gives back to the community by sponsoring and coordinating 5k races and volunteering as an amateur photographer. In 2012, she received an outstanding volunteer award from Kevin and Ashley Shortt (above, left) of the New Hampshire Cystic Fibrosis Center. During a recent fundraiser, the cameras were turned on Nylen while she helped some of the racers stuck in the mud (left). (Both, courtesy Marilyn Nylen.)

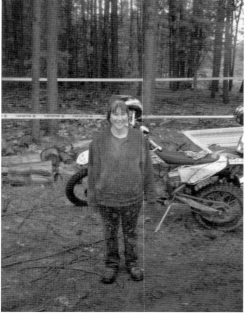

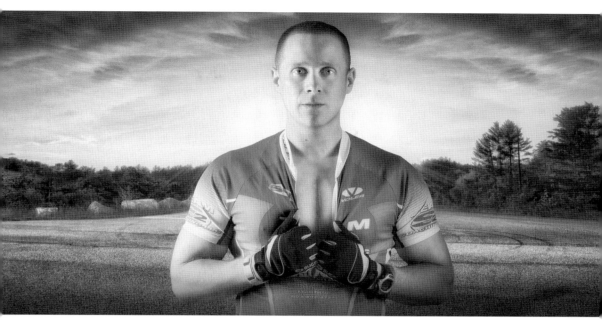

Jeremy Woodward, Triathlon Coach

At 34 years old, challenges are not unfamiliar to Jeremy Woodward. He has survived not one but two heart failures and subsequent open-heart surgeries at a young age. After his heart valve failed for the second time, Woodward went through another heart valve replacement. However, he is not a man who is easily sidelined. He has been using his strength and endurance toward fundraising efforts and, as a result, has earned numerous awards and recognition. Finishing an Ironman event and raising $200,000 for the New Hampshire Nature Conservancy just three years after his last open-heart surgery is but one of his many accomplishments.

Woodward, a fifth-degree black belt in kempo karate, continues to motivate others on the road to fitness and health. (Both, courtesy Kickpics and Jeremy Woodward.)

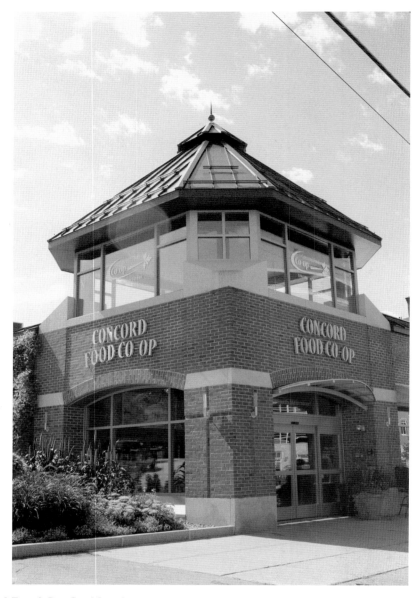

Concord Food Co-Op Members

In Concord, 5,000 people make a co-op strong. One would never guess by the current location that the Co-op has its roots in a buying club that started in the 1950s, as Marie Colbath remembers. The Super Duper Supermarket was Concord's first self-service, hole-in-the-wall grocery store, located on the corner of South State and Concord Streets. Customers brought their list of items to the counter, and store clerks would pack the orders for them to take home. The concept of a buying club was born, whereby the store would place wholesale orders, and customers would buy in bulk through the store. In the mid-1990s, the Co-op moved to its current South Main Street location, sharing the space with other businesses. In 2012, after the remodeling construction was completed, the Co-op enjoyed triple the amount of space. Combined with the second location in New London, it employs 85 people and has over 5,000 members.

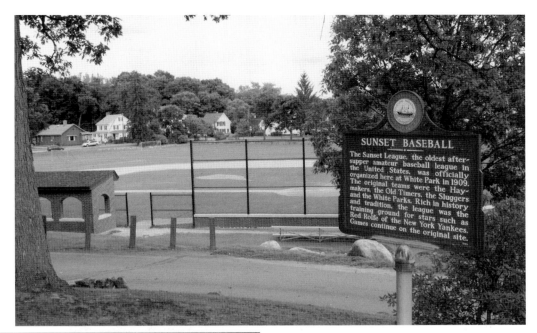

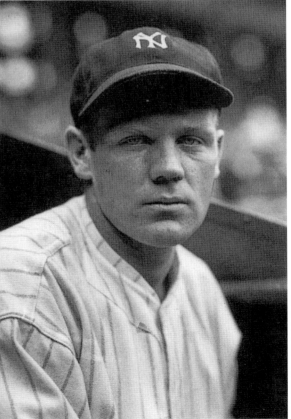

White Park Sunset League Baseball

In the heart of Concord, one of the oldest parks in New Hampshire is named after a prominent local couple, Nathaniel and Armenia White, who donated the land to the City of Concord in 1884. The park is an oasis of 23 beautifully landscaped acres where baseball is played almost every night in the summer. There were four teams when the Sunset League began in 1909. This after-supper league and the baseball diamond served as training grounds for big leaguers like Red Rolfe of the New York Yankees.

Robert Abial Rolfe, Major Leaguer

Third base has never been the same. "Red" Rolfe (1908–1969), a starting third baseman for the New York Yankees, got his start on the green grass of White Park. A graduate of Phillips Exeter Academy and Dartmouth College, Rolfe played with the Bronx Bombers from 1931 to 1942 and helped win four World Series in that time. He also coached Yale teams for four years and the Detroit Tigers. (Courtesy LOC.)

Eva May Crosby, Hospital Superintendent

Born in 1877, Crosby was a 1896 graduate of Concord High School. A descendent of Asa Emery, who served in the Army and Navy during the Civil War, she trained at the New Hampshire Memorial Hospital as a nurse and was its superintendent from 1903 to 1905. Crosby was president of the Concord Nurses Club from 1914 to 1916 and president of the Graduate Nurses' Association from 1915 to 1916.

Steve Birch, Boutwell's Bowling

Born and raised in Concord, Steve Birch, along with Boutwell's, is a North State Street fixture. Residents have been bowling there since 1968. After graduating from Bishop Brady High School in 1974 and working at the bowling alley, Birch bought the place from his father in 1986. He bought out his business partner 10 years ago and is now sole owner of the facility. Birch is proud of the family atmosphere and hosts many events, including birthday parties, bumper bowl, glow-bowl, and even weddings. In 1991, the scoring went from paper and pencil to computer. The only time Birch has not bowled candlepin was when he was on the pro tour and bowled 10-pin. Birch served in the New Hampshire Guard and is married with three grown children. He now sees third- and fourth-generation bowlers coming in to play.

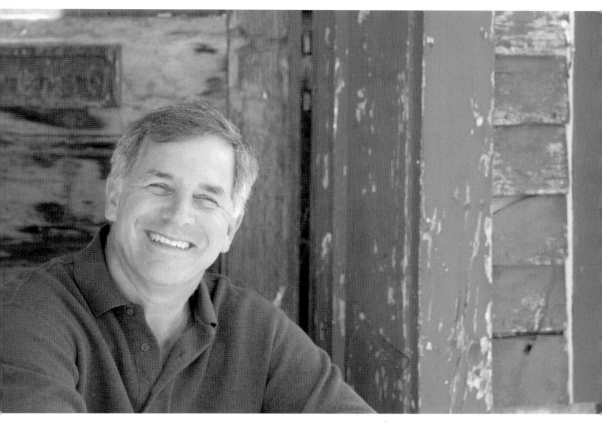

Gary Hirshberg, Stonyfield Farm

Hirshberg is chairman of Stonyfield Farm, the world's leading organic yogurt producer, and he is managing director of Stonyfield Europe, with organic brands in Ireland and France. He serves on several corporate and nonprofit boards, including Applegate, Honest Tea, Peak Organic Brewing, Late July, Quantum Design, Glenisk, the Danone Communities Fund, and the Danone Livelihoods Fund. In 2011, Pres. Barack Obama appointed Hirschberg to serve on the advisory committee for trade policy and negotiations. He is a cochair of AGree, an agricultural policy initiative formed by the Ford, Gates, Kellogg, Rockefeller, Walton, and other leading foundations. He is chairman and a founding partner of "Just Label It, We Have the Right to Know," the national campaign to label genetically engineered foods, and he is the coauthor of *Label It Now: What You Need to Know About Genetically Engineered Foods.* Hirshberg is the author of *Stirring It Up: How to Make Money and Save the World.* He has received 12 honorary doctorates and numerous awards for corporate and environmental leadership, including a 2012 Lifetime Achievement Award by the US Environmental Protection Agency. He is the husband of *Inc.* columnist and author Meg Hirshberg. (Courtesy Gary Hirshberg.)

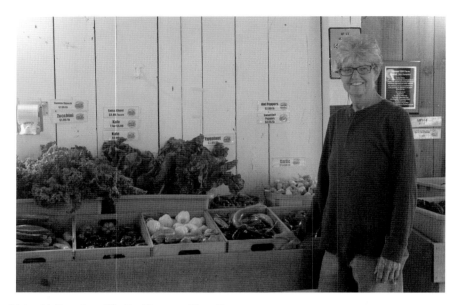

Jane Abbott Presby, Sixth-Generation Farmer

Named after Ezekiel Dimond, who fought in the Battle of Bunker Hill on June 17, 1776, Dimond Hill Farm has been a working farm for almost 200 years. Passed down through generations of Abbotts, the farm has been run by Jane Abbott Presby since she took over in 1998. She is particularly proud of the fact that more than 90 percent of Dimond Hill Farm is pesticide-free. Today, the 150-acre farm carries locally grown and produced items, including milk, meats, cheeses, and pies. Dimond Hill Farm is enjoying the resurgence in interest in locally grown foods. And, as a result of the efforts of many in the community, Dimond Hill Farm is held in an agricultural easement, which will preserve it for all to enjoy for generations to come.

Dr. Diane E. Benoit, DMD

A New Hampshire native, Dr. Benoit has practiced dentistry in New Hampshire for 25 years. She has learned to balance her successful dental practice with her marriage to husband Christopher while raising two children. She often feels pulled in many directions, as other mothers do, but she always has a smile for her patients. In fact, one patient left her practice because Dr. Benoit was too happy! (That is a true story.)

Dr. Benoit went on a humanitarian mission to Haiti and provided free dental care to hundreds of residents. Some walked up to three hours to her camp to have a tooth pulled. She did extractions from sunup to sundown in an area of extreme poverty. Everyone thanked her after the procedures. That experience made her appreciate her life in New Hampshire even more. Dr. Benoit does not have a favorite procedure, but does like to make a difference in someone's self-esteem by replacing or repairing a discolored tooth, filling a gap, or preparing a whole new set of teeth. In addition to the thousands of toothbrushes and supplies donated to local schools and groups, Dr. Benoit provides free dental care through Donated Dental Services, which includes cleanings and fillings or up to $20,000 of needed treatment.

Dr. Benoit has a big heart when it comes to kids. She was on the board of directors for Kids College until it closed, promoting and sponsoring programs for gifted children. She sponsors many local athletic and extracurricular programs, such as CHS ice hockey, theater, and wrestling, Pembroke Academy yearbook, and Bow Booster Club. She nurtures her own two children in her off-hours. Miranda, 14, enjoys dance and ice hockey. She wants to be a teacher when she finishes school. Nate, 11, enjoys ice hockey, soccer, and lacrosse. He wants to play in the NFL or work with his father in financial services.

Dr. Benoit now sees the children and grandchildren of her patients from 20 years ago, which speaks highly of her kind and gentle nature as a dentist.

Mary Gordon Thorne, Red Cross Organizer

As a Sunday school teacher of 44 years, Thorne was active in fundraising and organizing for countless nonprofits. She helped establish the Young People's Missionary Society and organized the YMCA Auxiliary. She established a free dental clinic in the public schools and helped grow the largest Red Cross chapter in the state. She was active in the Children's Aid and Protective Society and the Equal Suffrage League.

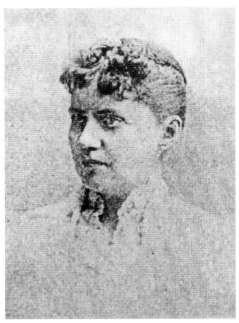

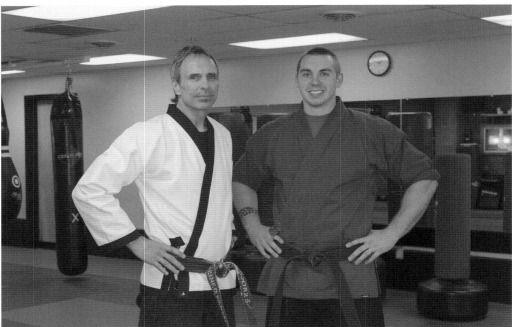

Jeff and Luke Hardy, Karate Teachers

Hard work and dedication define what Jeff Hardy (left) has done in the past 34 years of his life. He is a master black belt and teacher of kempo karate. He moved to his current Manchester Street location in 1989. Hardy started a program called Blue Star Projects, in which all the children enrolled in his school volunteer to do "Acts of Kindness" and receive recognition for their work. Hardy's wife, Mary, has joined him as the bookkeeper in his business, and his son Luke (right) is a trainer.

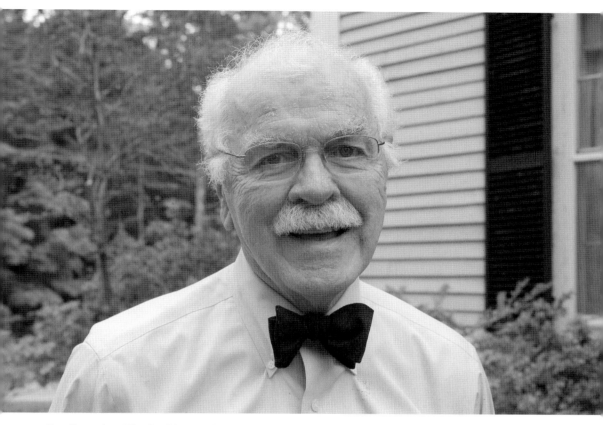

Dr. Douglas Black, Obstetrician Extraordinaire

It has been said that Dr. Black has delivered half of the babies in Concord. That may be a slight exaggeration, but it is certainly a testament to Dr. Black's 50 years as an obstetrician. In Concord, everybody knows his name. Dr. Black married while an intern at Indiana University Medical Center. He met his wife, a nurse at the same hospital, when she sternly corrected him for contaminating sterilized instruments. In those days, sterilization took staff several hours to complete, and he had undone all their hard work. He called her later that day and asked if she would date him. When someone asked him why he would call someone who had just yelled at him, he responded, "Just look at her and you'll know why." The rest is a wonderful love story.

After a residency in New York City and two years in the US Air Force at the end of the Korean War, Dr. Black arrived in Concord in 1963 by way of a friend who said the hospital was looking for a doctor. He established his practice and continued to deliver babies for the next 50 years, touching the lives of thousands of individuals. Dr. Black is especially proud to have served as president on the New Hampshire Board of Medicine for 10 years. He worked on regulating the behavior and peer reviews of doctors in New Hampshire. Dr. Black hand-ties all of his signature bow ties. No clip-ons allowed.

Harriet Patience Dame

As a 46-year-old nurse, Harriet P. Dame (1815–1900) left her hospital duties behind in Concord and marched with the 2nd Volunteer Infantry Regiment during the Civil War. She never missed a day of service in the four years she looked after the soldiers. Dame was captured and released twice and was buried with full military honors at Blossom Hill Cemetery. After the war, she worked in the Treasury Department for 32 years and retired at 84. Her portrait hangs in the state capitol building, and the Dame School is named after this heroic woman.

Gen Woodward, Gen's Dance Studio

If longevity is a sign of success, then Gen's Dance Studio is very successful. Woodward has spent 45 years teaching dance to children and adults in Concord. At age five, she started dancing, and by senior year in high school, she knew she wanted to teach. Just three days after graduating from Bishop Brady High School in 1968, she married her husband of 46 years and started a business. Woodward never stopped teaching except to have three children.

Gen has traveled to Virginia, Georgia, and Connecticut to participate in national dance competitions. She did all the choreographing of the dances and worked with parents to coordinate schedules and travel. She has a few students who went on to dance professionally and a few who were so inspired by her teaching that they opened their own dance studios. Woodward was state chairwoman of the New Hampshire Junior Miss and volunteered nine years for the competition. This organization helped high school seniors earn scholarship money for education.

Woodward loves to dance and teach, helping to build self-esteem and confidence in her third generation of students. Currently, her granddaughters Elian and Bryn are students in her class.

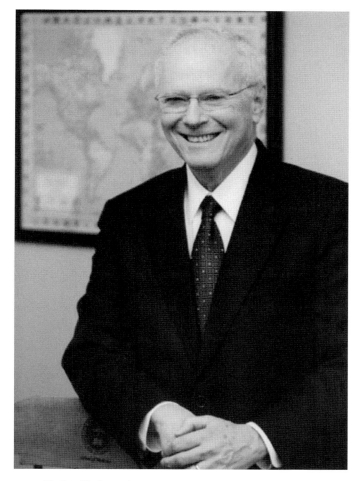

Harris A. Berman, Tufts University

Harris Berman, MD, is dean of Tufts University School of Medicine and professor of public health and community medicine. Prior to that, he was vice dean of the medical school, dean of public health and professional degree programs, and chair of the Department of Public Health and Family Medicine. Before coming to Tufts University, he was a pioneer in the development of managed care in New England, and for 17 years, he was the chief executive officer of Tufts Health Plan. Before joining Tufts Health Plan, Dr. Berman cofounded the Matthew Thornton Health Plan in Nashua, New Hampshire, one of the first HMOs in New England. He is currently a member of the board of directors of Tufts Health Care Institute, New England Healthcare Institute, Tufts Medical Center, and Tufts Health Plan. Before that, he was a member of the board of AvMed Health Plan, a nonprofit plan in Florida for seven years, and Hebrew Senior Life. Dr. Berman has international experience as a Peace Corps physician in India and as a consultant to the US Agency for International Development in several international projects. At Tufts, he spearheaded the expansion of the Global Health Program and has helped grow the affiliation between Tufts and Christian Medical College in Vellore, Tamil Nadu, in southern India, into many new areas of cooperation. A graduate of Concord High School, Harvard College, and Columbia University College of Physicians and Surgeons, Dr. Berman served as a resident on the Harvard Medical Service of Boston City Hospital and Tufts–New England Medical Center and had an infectious disease fellowship at Tufts–New England Medical Center. He is a fellow of the American College of Physicians. (Courtesy Tufts University School of Medicine.)

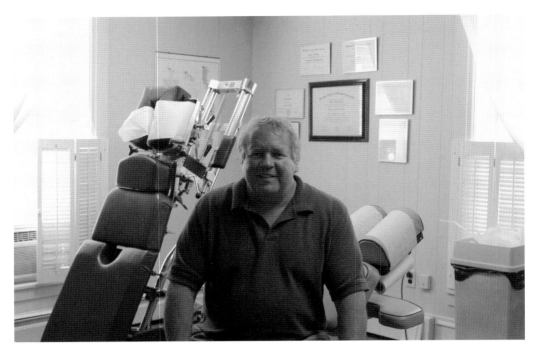

Dr. John Sellar, Chiropractor

After hurting his back and being adjusted by a chiropractor, John Sellar knew what he wanted to be in life and studied at Sherman College of Chiropractic 20 years ago. Voted the Concord region's best chiropractor nine years in a row, Sellar's clinic is the only one in the area to use ProAdjuster, a computer that analyzes and treats the body as never before. With his skill and expertise, Sellar has brought many patients back to a higher quality of living and was recognized as a top chiropractor in 2014.

Jacob Harold Gallinger, Physician

Gallinger, one of 12 children, worked in the printing trades before attending New York Homeopathic Medical College. He was an active member of the Republican Party and was on the state committee for 18 years, serving in the New Hampshire House for six years and in the state senate from 1878 to 1880. In the administration of Gov. Nathaniel Head, he served as the surgeon-general. When Gallinger ran for national office, he was elected to the House and Senate, being the oldest member of Congress at the time.

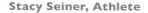

Stacy Seiner, Athlete

Sports have always been a part of Stacy Seiner's life, ever since she played her first T-ball game at the age of six. Although she played soccer in high school and college, softball was the sport she would excel in. She began playing Little League in Pembroke, where she pitched on the all-star team that won the state tournament in 1999 and 2001. Seiner's softball career continued in high school, where she pitched and played center field. In 2005, she earned the role of starting pitcher on the Pembroke Academy team and helped advance it to the final four in Division II softball. During her high school career, she was presented the MVP award in 2004 and 2005, as well as the Sportsmanship Award in 2004.

She graduated from Wheelock College in Boston in 2009 with a bachelor's degree in psychology. In her senior year, she was a member of the first Wildcat softball team to ever compete in the New England Collegiate Conference (NECC) tournament. She received the Wildcat Award and Coaches Award during her four years as a starting pitcher/third baseman, and she was chosen as captain in both her junior and senior years.

After graduating college, Seiner decided she wanted to pursue a degree in the athletic field and become a softball coach in New Hampshire. She is currently pursuing her master's degree in athletic administration at Ohio University. She is the assistant coach at New Hampshire Technical Institute (NHTI), where she mentors and advises students on how to balance sports and academics. (Courtesy Kirsten E. Arends.)

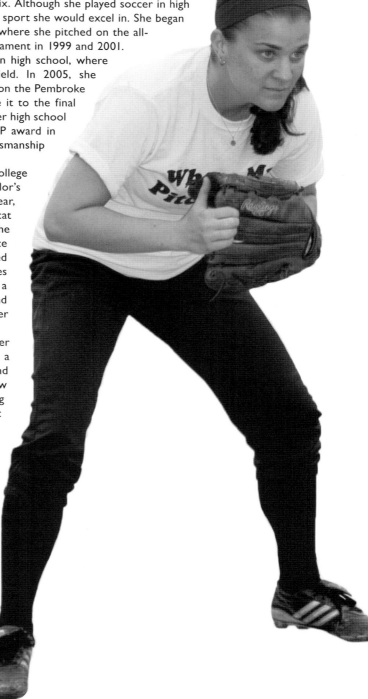

Lilian Carpenter Streeter, Children's Advocate

Carpenter, the daughter of Chief Justice Alonzo Carpenter, was active in several children's charities and women's clubs in the early 1900s. She was chair of the New Hampshire Children's Commission from 1913 to 1915. The reports she wrote during this time were in high demand by social workers in other states. She was asked by Pres. Theodore Roosevelt to attend the National Conference on Dependent Children, held at the White House in January 1909.

Benjamin F. Prescott, Governor

Prescott grew up working the family farm. He was an only child, and his family lineage can be traced back to the American Revolution. Prescott (1833–1895) attended Phillips Exeter Academy and Dartmouth College, where he was recognized as a great orator. He taught for a short time before joining Bellows Law Firm in Concord and became the associate editor of the *Independent Democrat* for six years to fill in for George Fogg, who went on to be an ambassador to Switzerland. Prescott was deeply opposed to the institution of slavery and gave many persuasive speeches as he traveled throughout New Hampshire. About 1859, he was elected to the Republican State Committee and served as secretary, a position he held for 15 years. As governor, he was described as approachable and respected by both parties, and he was called upon to give speeches at private and public functions. The governor revised many of the laws of the state, and under his administration, a new prison was built. He continued farming on the family homestead in his retirement.

CHAPTER TWO

Main Streets

Concord would not be what it is today without the dedicated merchants and people involved in building a strong economic community. The transition from a hub of manufacturing and agriculture to a services-based city began 100 years ago. Slowly, manufacturing on a large scale was phased out and farms were sold off to make room for the influx of people and the increased need for housing. Merchants set up shop on Main Street and offered household appliances and tools that were manufactured elsewhere. These devices made post–World War II life much easier and left time for people to pursue other interests.

Among those mentioned in this chapter is Gretchen Goodwin, whose parents, Pete and Jo, started a pushcart business in 1976 and expanded to several locations. They handed down the business to Gretchen, who can be found serving lunch to passersby on Main Street. The service industry is fast becoming a foundation on which Concord thrives. The people studying the projections for where Concord will be in the next 25 to 50 years are using that knowledge to bring together an assortment of attractive and inviting businesses to downtown. Agnes Ellingwood at L&B Tailoring will take a customer's idea for a new set of drapes and make it a reality. Michael Hermann at Gibson's Bookstore will order any book a customer seeks if it is not in stock.

A stroll down Main Street reveals the changes that have occurred in the 30 years since Susan McCoo of Capitol Craftsman opened her shop. Many groups of dedicated people care deeply about the survival and growth of this capital city. And while civic leaders like Byron Champlin and business owners like Tom Arnold ponder how to continue to cultivate economic growth and stabilize the region, Concord celebrates its 250th anniversary. It is a time to reflect on the past and assess where the town has been in order to map out the future and plan where it is going. It is quite clear that, as long as there are groups of caring, thoughtful people in the community who can convey a vision for what Concord might look like in the future, success will likely follow.

Michael Hermann, Gibson's Bookstore (BELOW AND OPPOSITE PAGE)
Gibson's was established in 1898, and Michael Hermann is only the fifth owner of the family-oriented bookstore with deeps roots in the community. He purchased it in 1994 after moving to Concord from New York City. Hermann graduated from Harvard University and is an avid reader. He is a wealth of information and can acquire hard-to-find books. Concord's only independent bookstore, Gibson's specializes in intelligent entertainment. With thousands of titles in stock, the variety will satisfy even the most voracious of appetites. Since the store moved to its new, 10,000-square-foot location in September 2013, it offers an expanded collection, café, author signing events, and comfortable seating. Customers' needs are important to Hermann, and he works to fulfill any special book requests. Hermann has served on numerous nonprofit boards, including the New England Independent Booksellers Association.

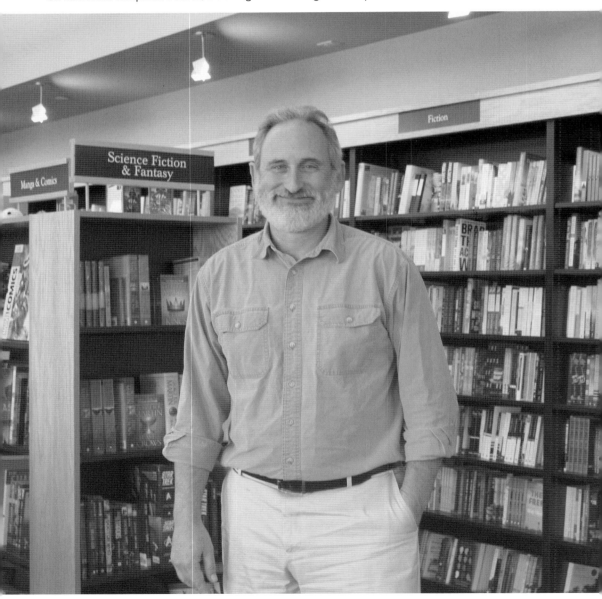

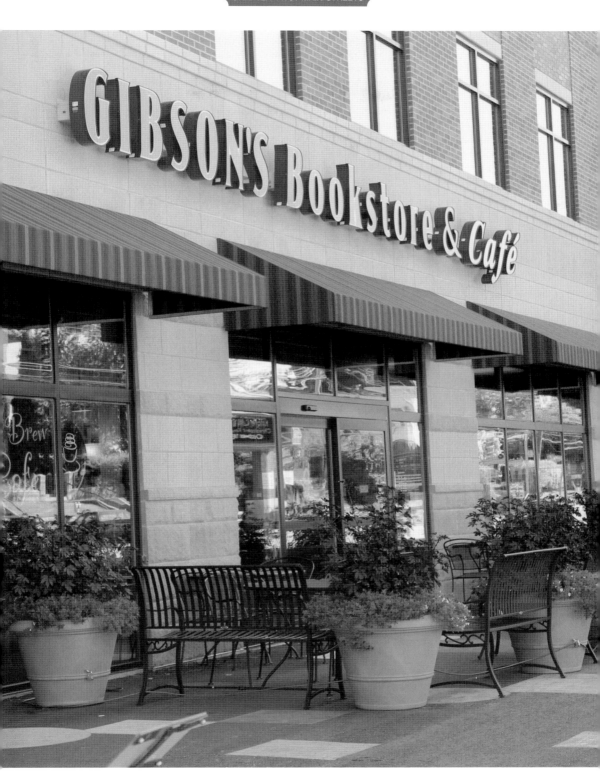

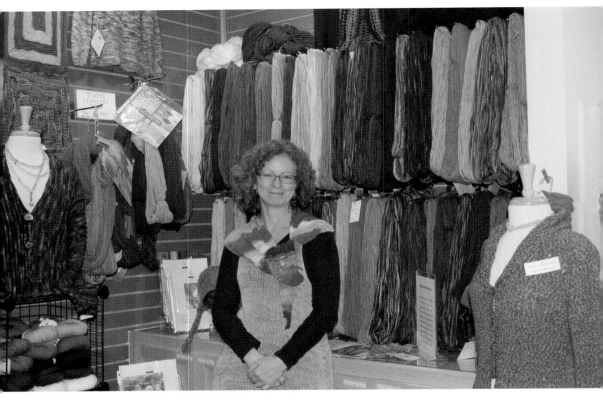

Marci Richardson

Marci Richardson has over 30 years' experience in the fiber arts. She opened the Elegant Ewe 15 years ago to fill a niche market of knitting and crocheting enthusiasts. At her establishment, faithful followers can learn about different types of yarn or take a class. She has had students attend from as far away as England. Richardson sponsors the "Click for Babies" campaign and collects baby hats made by customers to donate to hospitals, raising awareness of shaken baby syndrome.

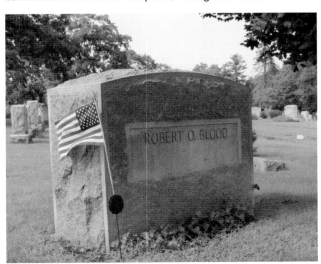

Robert O. Blood, Governor

Dr. Blood received his medical degree from Dartmouth College and entered World War I as a lieutenant in the Army Medical Corps. After the war, he established his medical practice and entered politics, serving in the New Hampshire House of Representatives, Senate, and as senate president in 1939–1940. Blood (1887–1975) was elected governor in 1940, serving two terms. Under his administration, the state deficit was eliminated.

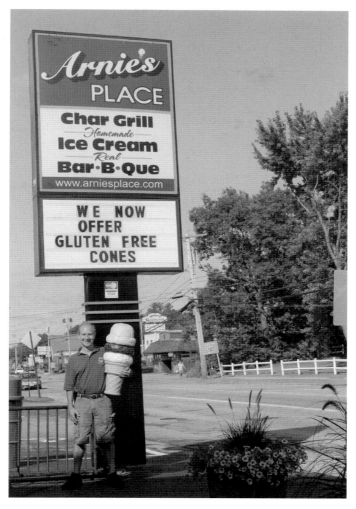

Tom Arnold, Arnie's Ice Cream

When the local Dairy Queen went bankrupt in 1991, Tom Arnold rented the space to sell Christmas trees. That first season, he sold 150 trees. Now, 25 years later, he sells about 2,000 Christmas trees and wreaths. Arnold's father was a manager for a local ice cream shop and got him started in the business of selling ice cream. Since 1964, when the Arnold family moved to Concord, the only time Tom Arnold has left the city was to attend college. He is happily married and can honestly say he loves to go to work. That sentiment is reflected in the fact that his employees stay on much longer than the normal length of a summer job. Some employees have been there for over 10 years working part-time; one employee has worked there 17 years and has a master's degree. The employees like working for Arnold, who is described as fun, caring, and having a great sense of humor. He has officiated over weddings for three of his employees—Arnold is a justice of the peace—and he once held a wedding in the back room. Every Tuesday night in the summer, the parking lot at Arnie's is full of classic cars, as Arnold hosts a local club on the premises. Arnie's makes its own ice cream, and Tom cures all the meats on-site. His menu has expanded in the last few years, and everything is cooked fresh. He has enthusiastically supported Little League teams every year since the late 1990s, and he is generous to a fault. It has been rumored that whenever someone is down on his luck, Arnold is nearby, doling out $20 bills (the reader did not hear about it here!).

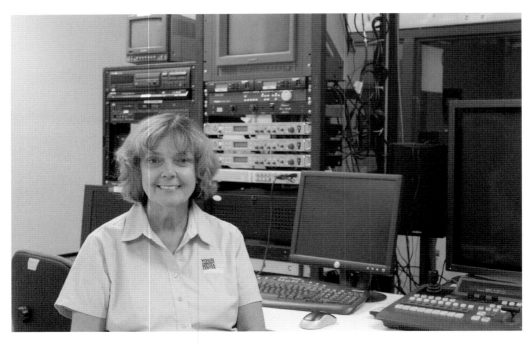

Doris Ballard, Concord Community Television

Concord's noncommercial television station is funded by cable television franchise fees and is a full-fledged nonprofit media technology center. Ballard got her start in business in 1980, when she and her husband, Norman, started a Halloween costume shop and then purchased the building that would become Ballard's Ice Cream Sandwiches and More. Ballard began volunteering for CCTV in 2001 and took on the role of outreach and development director. In 2010, she assumed the role of executive director and increased the station's offerings. There are low-cost classes on editing, filmmaking, and production. Anyone can create programming for the station. Ballard grew a fledgling CCTV from a two-room office to what now is a small wing of Concord High School and established a second location in space at the Parks and Recreation Dame Building.

Tudor Richards, New Hampshire Audubon

The New Hampshire Audubon celebrated its 100th anniversary in 2014. Tudor Richards, hired in 1968 into the organization's first paid position as executive director, was instrumental in moving the headquarters from Main Street offices to the property on Silk Farm Road in 1973. Richards held the position for 35 years while adding new staff and building and diversifying the nonprofit's offerings. (Courtesy New Hampshire Audubon.)

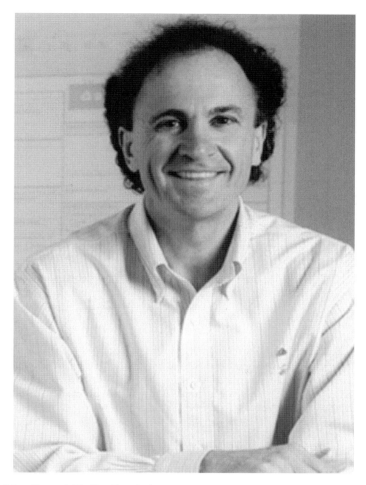

Tom Raffio, Northeast Delta Dental

Thomas Raffio is president and chief executive officer of Northeast Delta Dental, the Concord-based dental insurance company that administers dental benefits for nearly 770,000 people in Maine, New Hampshire, and Vermont. Under Raffio's leadership, his company was named one of the *Business New Hampshire Magazine* Best Companies to Work For in New Hampshire and one of the Great Place to Work Institute and the Society for Human Resources Management (SHRM) 25 Best Small Companies to Work for in America, each for five consecutive years, among the many awards with which it has been recognized. Raffio is a graduate of Harvard University, has an MBA from Babson College, and is a fellow of the Life Management Institute. He is a 1997 graduate of Leadership New Hampshire. Since moving to New Hampshire in 1995, Raffio has been an engaged civic leader. He is currently the chairman of the New Hampshire Board of Education and is a member of the State Workforce Investment Board. He is incorporator and chairman of the board, Granite State Quality Council; chair, New Hampshire Coalition for Business and Education; chair, Bow Schools Foundation; board member and former chairman of the board, New Hampshire Business Committee for the Arts; board member and former chair of the board, Early Learning New Hampshire; board member, New Hampshire Fisher Cats Foundation; and advisory council member, Capital Area Race Series. He is also a member of the NH Scholars Leadership Board, where he also serves as a champion. In 2013, Raffio coauthored *There Are No Do-Overs: The Big Red Factors for Sustaining a Business Long Term* with NBA hall of famer Dave Cowens and former Northeast Delta Dental colleague Barbara McLaughlin. (Courtesy Northeast Delta Dental.)

Jessica Fogg, Nonprofit Advocate

Fogg started an event-planning and promotions business with the goal of making significant contributions to the community. She serves on the board of directors for the Crisis Center of Central New Hampshire and Hearts for Kindness and is an advocacy council member for Girls Inc. Concord. She runs an annual food drive for the Take-a-Tote program, which feeds hungry elementary school children. (Courtesy Rebecca Kinhan.)

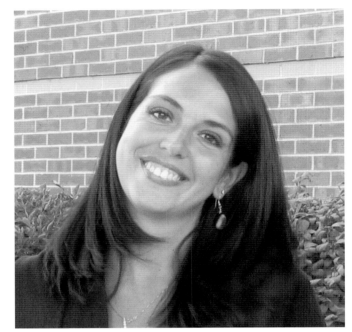

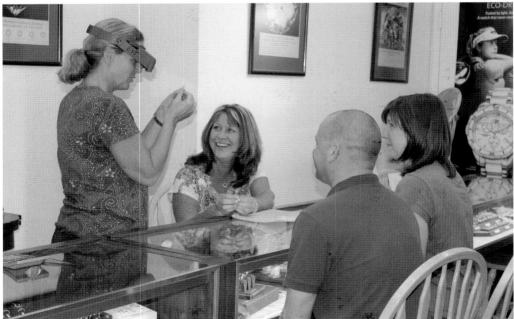

Susan McCoo, Capitol Craftsman and Romance Jewelers

For over 32 years, McCoo and her husband, David Dingman, have brought together over 200 craftspeople in one place selling all-American handmade crafts. They added the jewelry store 17 years ago and help restore or rebuild family heirlooms. The most unusual piece ever created was a horse tooth pendent. Here, jeweler Eileen Tetu (left) examines a diamond as store manager Cheryl Scaramuzzi (center) looks on with customers.

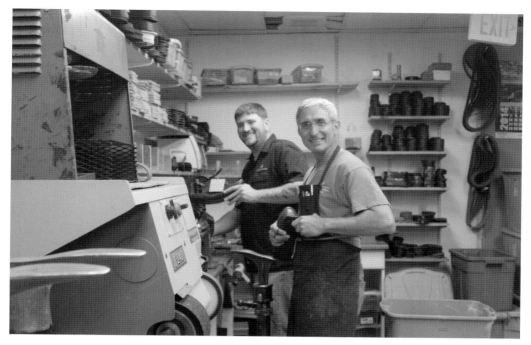

D.J. Annicchiarico, United Shoe Repair
United Shoe Repair dates back to 1909, when Annicchiarico's great-grandfather Michelangelo started a traveling shoe-repair service for the Greater Concord area. The skills to mend and refurbish not only shoes and boots but leather coats, bags, and apparel were handed down to D.J. (left) through four generations of master cobblers. Uncle Peter Annicchiarico (right) helps out in the shop.

William Eaton Chandler
Chandler, a lawyer and statesman, served in the New Hampshire House of Representatives from 1862 to 1864 and as Speaker in 1863–1864. As secretary of the Navy in 1882, he initiated reforms to make that branch of the armed forces more progressive. He worked on a committee to erect a statue of Pres. Franklin Pierce on the lawn of the statehouse, accomplishing that in 1914. Chandler married Lucy Hale in 1874, several years after the death of her fiancé, John Wilkes Booth, Pres. Abraham Lincoln's assassin.

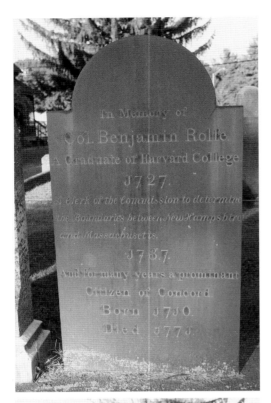

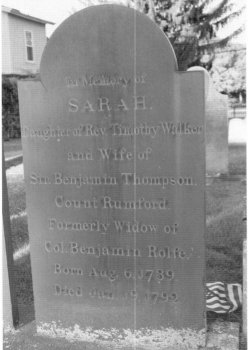

Benjamin Rolfe and Sarah Walker
Rolfe (1710–1771), a wealthy Harvard graduate, married Sarah Walker (1739–1792), the daughter of Rev. Timothy Walker, one of Concord's earliest settlers. They lived in the Rolfe-Rumford House by the Merrimack River. When Colonel Rolfe died in 1771, his wife married Benjamin Thompson, who later became Count Rumford. Their daughter Sarah Countess Rumford would inherit her mother's estate upon the death of her half-brother, Paul Rolfe.

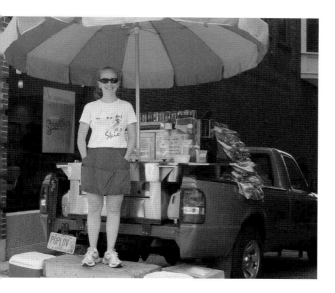

Gretchen Goodwin

Year-round, Gretchen Goodwin prepares hot dogs for customers from her pushcart on North Main Street. The bright orange umbrella has been there since 1978, when her mother was serving up hot dogs. Gretchen and her sister were New Hampshire Interscholastic Athletic Association (NHIAA) doubles tennis champions for the 1989 Plymouth High School team. She gets her sporting genes from her great-grandfather, a catcher and manager for the Boston Red Sox. Bill Carrigan was one of only two managers to lead the Red Sox to a World Series title twice. Gretchen delivers a great dog from mid-morning to early afternoon, Monday through Saturday, all year long.

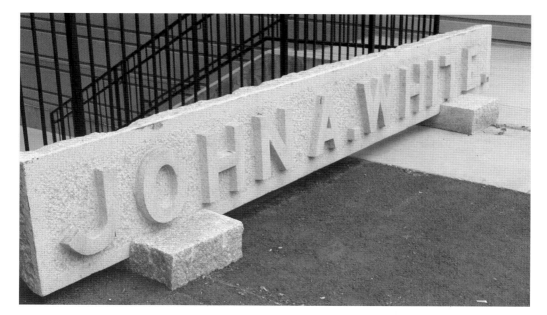

John A. White, Machinist

The son of Nathaniel and Armenia White, John was a machinist and ran a company called Concord Machine Works from about 1877 to 1911. The firm made table saws, band saws, lathes, carriage- and car-building machinery, and more. White held several patents for improvements to various pieces of machinery.

Sherman Adams, Governor

Adams, a US Representative in 1947, was elected governor in 1949. In 1952, he was asked to be Dwight Eisenhower's White House chief of staff, a position he took very seriously. Adams (1899–1986) was forced to resign, however, after five years for accepting a fur coat from a Boston firm that was being investigated by the Federal Trade Commission.

Agnes Ellingwood, Seamstress

Ellingwood has been sewing since she was nine years old. She is a trained seamstress and a breast-cancer survivor. After working for other sewing shops, Ellingwood decided to open her own store, L&B Tailoring, on South Main Street. She calls herself crazy for buying her current shop, sight unseen, only 11 months after her diagnosis. But looking back, it is the best thing she ever did. Not knowing what the future held for her in 1999, she decided it was important not to have any regrets. Ellingwood has been there for 14 years, making wedding dresses, drapes, and cover cushions and sewing hems. She has had a few brides forget to pick up the wedding dress. Desperate brides track her down. More than once, Ellingwood has been at a weekend dinner and was called by police to open her shop.

Ari B. Pollack, Esq.

Pollack is the president and shareholder-director of the law firm Gallagher, Callahan & Gartrell, PC. At the North Main Street firm, Pollack represents business, construction, land-use development, and environmental clients on a variety of permit, development, environmental, and litigation matters. He has been with the firm 15 years and has been president and managing director for the last four years.

Pollack continues to be listed in Woodward/White, Inc.'s *Best Lawyers in America* for real estate, land use, and zoning, and he was selected by Best Lawyers as Concord's 2013 Lawyer of the Year for land use and zoning law. He was also named to the Super Lawyers 2012 list of New England Rising Stars for land use/zoning. He was among the *New Hampshire Union Leader's* 2012 40 Under 40 class. As legal counsel and registered lobbyist, Pollack works to keep jobs in New Hampshire by challenging legislation that would drive up the cost of construction, leading to a lack of affordable housing for citizens. Pollack represents clients in all phases of construction, permitting and development, including conceptual business and development planning, contractual negotiations, and the retention of qualified land-use and environmental experts.

Through the firm, Pollack is an active member of the Home Builders and Remodelers Association of New Hampshire and the National Association of Home Builders, and he serves on the National Association of Home Builders' Legal Action Committee, Litigation Oversight Group, and Legal Action Network for Development Strategies (LANDS).

Pollack is a commissioner and past chairman of the board of commissioners of the Concord Housing and Redevelopment Authority. He was also a member of Concord 2020, a community advisory group dedicated to improving the workability and livability of the City of Concord. He graduated from Colgate University in 1994 and Boston University School of Law in 1997. He is a member of the bar in the state of New Hampshire and the commonwealth of Massachusetts. Attorney Pollack lives in Concord with his wife, Jessica, and their three children.

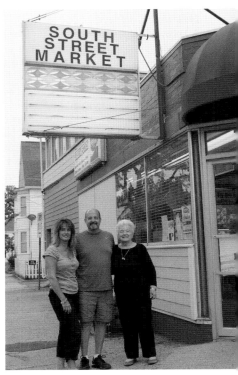

The Bashios, South Street Market

Magdalene Bashios, seen at right in the photograph on the right and below, arrived in Concord in 1958 and has been running the Greek specialty market ever since. Her husband, Peter, now deceased, took over the market from his father, Spiro, who had been running it since 1947. Magdalene's son, Jim (right, center), and his wife, Robyn (right, left), took over managing the market in 1991. The store has been on South Main Street for 67 years and three generations. (Below, courtesy Bashios family.)

Nathaniel White

A knowledgeable businessman and devoted husband, Nathaniel White (1811–1880) left his homestead at 14 years old with just the clothes on his back. He worked a short time at the Columbian Hotel in Concord and then secured a job as a stagecoach driver. After saving his money for several years, he bought the business, which transported goods back and forth between Concord and Hanover. He expanded his successful services to Lowell, Massachusetts, and then to Boston in later years. In 1836, White married Armenia Aldrich on her birthday, and the two shared many philanthropic interests. They established the New Hampshire Asylum for the Insane, the Home for the Aged, and the state reform school. White served on numerous boards and was a trustee of the Loan and Trust Savings Bank of Concord. In 1846, he purchased about 400 acres in southwest Concord and began farming. White served in the state legislature and was a committed abolitionist who offered his home as a refuge for slaves fleeing the South. He freely provided them with food, care, and money as they made their way to freedom.

Amanda Grappone Osmer, Grappone Automotive
Osmer is the fourth generation of her family to own and operate Grappone Automotive, a group of five car dealerships, a wholesale parts operation, and a collision center in Bow, New Hampshire. Team Grappone operates in a learning environment in which the whole person is fostered, with the end goal of building lifelong relationships by serving with integrity, kindness, and respect. The Grappone family continues its long tradition of giving generously to the Concord community. Amanda lives in Canterbury with her husband, three kids, two dogs, and an ever-changing number of homing pigeons. (Courtesy Grappone Companies.)

Benjamin Ames Kimball
A prominent figure and highly regarded businessman, Kimball got his start as a master mechanic for the Concord Railroad. He started a business manufacturing brass and iron castings and car wheels. He was founder and president of Cushman Electric Company. Kimball (1833–1920) was a member of the New Hampshire House in 1872 and the Executive Council in 1884 and a delegate to the Republican National Convention in 1892. He was on the committee to erect the State Library building in 1890 and served on numerous bank boards as president or trustee of the bank. The Kimball House (below) is appreciated for its fine display of ornate woodworking. It is located beside and managed by the Capitol Center for the Arts and is used for weddings, business meetings, and special events. (Below, courtesy Capitol Center for the Arts.)

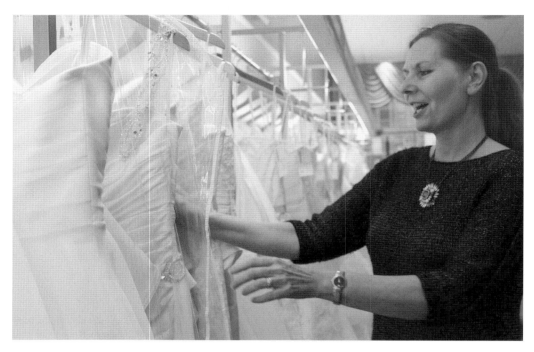

Helen Dionne, Business Owner

A Day to Remember Bridal Shoppe started as a small, in-home business. Helen Dionne quickly outgrew her surroundings. A building in downtown Concord that had been home to a bridal shop for 70 years then became Dionne's. She has donated hundreds of prom dresses to the Cinderella Project of New Hampshire allowing financially disadvantaged students to attend their high school formals.

Byron O. Champlin

Champlin is program officer for the Lincoln Financial Foundation. He oversees national media relations and communications for the Lincoln Foundation in addition to his local grant-making and community-relations responsibilities in Concord. He is involved in multiple community and economic initiatives in Concord and New England. Champlin sits on the board of many nonprofits, including New England Foundation for the Arts, and is currently chairman of the Concord Chamber of Commerce. (Courtesy Byron O. Champlin.)

CHAPTER THREE

Education

Education comes in many forms. Nathaniel Bouton, the state historian, wrote volumes about the history of Concord and the people who lived here in the late 1800s. Formal education through schools and colleges, or informally through music or religion or life events, offers lessons that can be passed on to future generations.

The people in this chapter are responsible for expanding horizons and broadening minds, in some cases demonstrating bravery in the face of adversity. Rev. Enoch Coffin came to the Plantation of Penny Cook in 1726 with the first group of settlers. No one knew what would come of their lives in this new place. Reverend Coffin performed the first religious ceremony on the "Intervale" in East Concord. There is a monument at West Sugar Ball Road to commemorate that special day.

Paul Giles dedicated his life to teaching. When he was not teaching music at the University of New Hampshire, he offered private lessons in his free time. As director of the Nevers' Band, his music brought to life the composers who wrote their pieces with great emotion. What better way to experience this than through free concerts on the statehouse lawn and other locations in the summer months? The band has ties to the Civil War era, which sparks listeners' imaginations when Tchaikovsky's *1812 Overture* is playing. The Nevers' Band tradition continues today.

Concord residents can learn from the experience of great leaders who demonstrated bravery during the Civil War, World War I, and World War II. Nathaniel Gove, 13, marched alongside adults during Civil War battles. Edward H. Brooks, a World War II hero, worked directly with Dwight D. Eisenhower. Through education of all kinds, society can only become more peaceful and civilized.

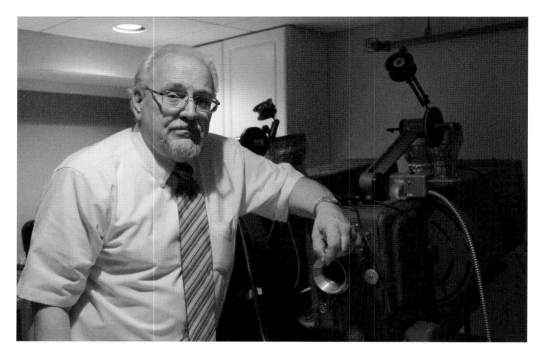

Barry Steelman, Film Historian
In 1967, Steelman started Cinema 93 as a commercial movie theater. Throughout its history, Steelman was at the helm, navigating sometimes dangerous waters. Strong competition in 1980 forced the theater to change to an art/repertory venue playing independent titles and foreign-language films. Steelman is a veritable catalog of movie titles and actors' names. Cinema 93 closed its doors, but Steelman continues working with his passion for movies at the Red River Theatre.

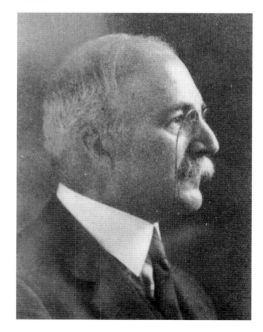

F. Beach White
Teacher and master at St. Paul's School, White (1872–1948) lived in the small farmhouse that was to become the home of the Audubon Society. He was the author of *The Birds at Concord* (1924) and served as Audubon president from 1935 to 1942. (Courtesy New Hampshire Audubon.)

Kristin J. Forbes, PhD

Valedictorian of Concord High School in 1988, Forbes went on to a distinguished career in economics. She graduated summa cum laude from Williams College and earned her doctorate from Massachusetts Institute of Technology in 1998. An Academic All-American in tennis and squash, Forbes was awarded Teacher of the Year from Sloan School of Management at MIT in 2008–2009 and has received abundant awards throughout her career. She has served on numerous advisory boards and was a member of the White House's Council of Economic Advisors. Forbes was recently named by the International Monetary Fund to the list of 25 top international macroeconomists under the age of 45. They will help shape the way people think about the global economy. (Courtesy Kristin J. Forbes.)

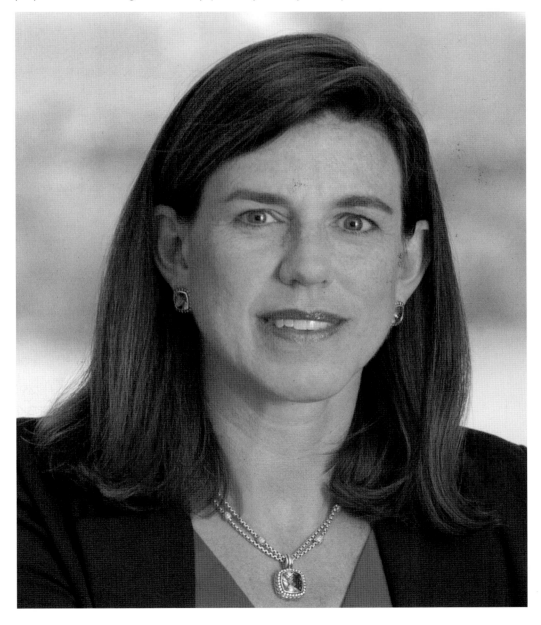

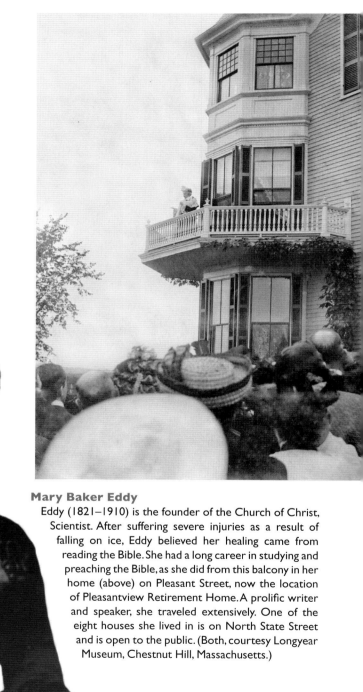

Mary Baker Eddy

Eddy (1821–1910) is the founder of the Church of Christ, Scientist. After suffering severe injuries as a result of falling on ice, Eddy believed her healing came from reading the Bible. She had a long career in studying and preaching the Bible, as she did from this balcony in her home (above) on Pleasant Street, now the location of Pleasantview Retirement Home. A prolific writer and speaker, she traveled extensively. One of the eight houses she lived in is on North State Street and is open to the public. (Both, courtesy Longyear Museum, Chestnut Hill, Massachusetts.)

Edward Warren Rollins
Rollins graduated from MIT in 1871 as a civil engineer. He was the eldest son of Edward H. Rollins, a US senator. Very active in banking and the railroads, Edward Warren Rollins (1850–1929) helped start Denver Electric Light Company and was president of the investment firm started by his father. He was president of the New Hampshire Association of Technology and donated $25,000 to the Wentworth Hospital in Dover in memory of his daughter-in-law.

Nathaniel Head, Governor

As quartermaster of the state during the Civil War, Head used his own money to procure supplies for the troops and to pay clerks working in his office. He accurately recorded every name and the history of all the soldiers and field officers during the war. Head (1828–1883) was the first adjutant general to establish an official plaque to give to veterans commemorating their service. He personally offered financial support to the "boys in blue" and was known as the soldier's friend. Head ran for governor in 1875, but because of a spelling error in his name on the ballots, the votes for him were technically not valid and were thrown out. After finally being elected in 1879, he weighed in on the Buzzell murder case and the death penalty and saw the completion of the new state prison.

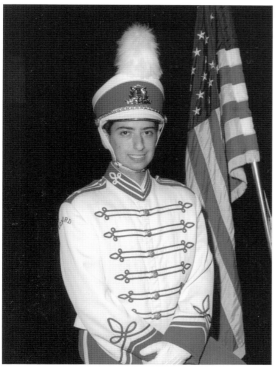

Daniel C. Courtney III, CHS Marching Band

In the left photograph, Courtney, CHS class of 2004, displays one of the new uniforms, complete with plumes, purchased after intensive fundraising efforts by members of the award-winning Concord High School Marching Band. The band embodies what hard work and dedication can lead to. The members work creatively at fundraising and are constantly practicing so that they may be invited to band competitions and parades all over the United States. The band marches and plays in almost any weather. Below, the 150-member band marches in Concord's Memorial Day Parade in 2014. The photograph was taken from the balcony of Mary Baker Eddy's home on North State Street.

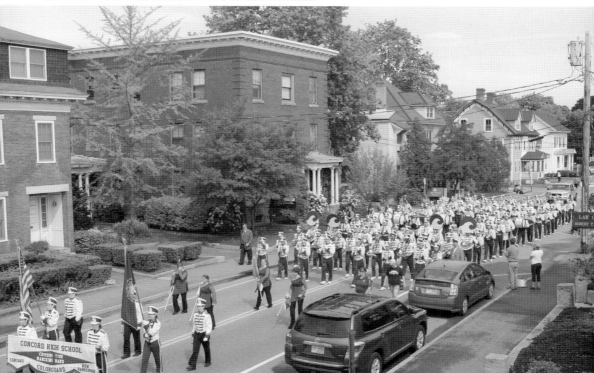

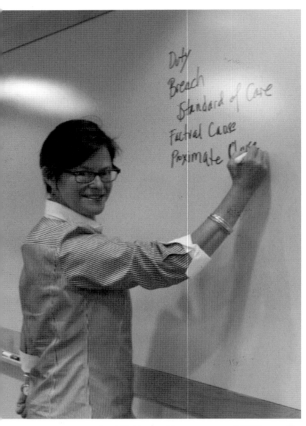

Sophie M. Sparrow, Law Professor

Sparrow is nationally recognized as an innovative leader in legal education, being named one of the 25 most influential leaders in legal education in 2012 and 2013. The coauthor of books on teaching law, including *What the Best Law Teachers Do* (2013), *Teaching Law By Design* (2009), and *Techniques for Teaching Law 2* (2011), she won the inaugural Award for Innovation and Excellence in Teaching Professionalism in 2004, taught as a Fulbright Scholar in India in 2012, and worked with the American Bar Association's Rule of Law Initiative in Jordan in 2014. Since 2002, she has conducted over 100 workshops for professors, administrators, lawyers, and judges in the United States, Canada, India, Bhutan, Mexico, and Jordan on topics such as active learning, team-based learning, assessment, metacognition, professionalism, professional development, legal education, and legal writing. An innovator since she started teaching law in 1998, Sparrow designed and ran the University of New Hampshire (UNH) Law's writing program for 10 years, helped design UNH Law's Daniel Webster Scholar Honors Program, and was one of the founding members of Arizona Summit School of Law. Her best teachers are her two children.

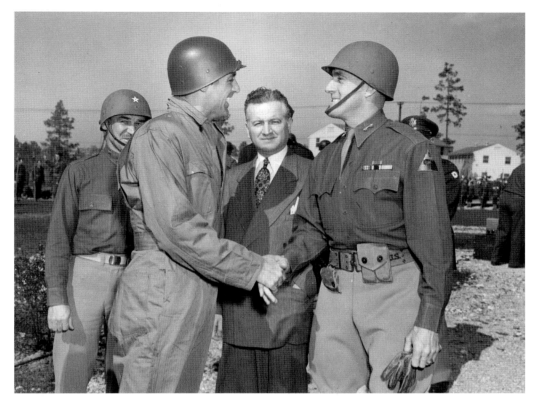

Edward H. Brooks
A highly decorated veteran of World War I, World War II, and the Korean War, Brooks (1893–1978) led Army forces in the invasion of Normandy. He was a member of CHS class of 1911 and went on to become a civil engineer. When the United States entered World War I, Brooks was called up for active duty. Here, he is seen greeting Clark Gable (left). (Courtesy LOC.)

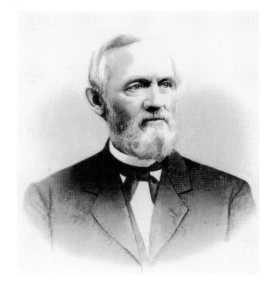

Oliver Pillsbury, Teacher
Born in 1817, Pillsbury grew up as a farmer until his late teens and did not go to school until he was injured in an accident that rendered him incapable of performing his farming duties. He excelled at his studies and recovered from his injuries, taking an interest in teaching. Pillsbury started a private school and was elected as a ward alderman then to the Governor's Council in 1862. He served as insurance commissioner under Gov. Onslow Stearns in 1869, advocating for citizens' rights.

Mary Parker Woodworth
The first female New Hampshire graduate from a four-year college, Woodworth was the president of the Woman's Club from 1897 to 1899. She was the first female school board member, serving nine years until she declined to run again. In 1873, she married Albert B. Woodworth, who became the mayor in 1897. Mary Parker Woodworth (1849–1919) devoted her life to teaching and education.

Rev. Dr. Nathaniel Bouton, State Historian, 1866–1877
Pastor of the First Congregational Church from 1825 to 1867, Bouton was a minister for 40 years. In 1856, he published an extensive and complete history of Concord. He established a Sunday school for religious education and traveled throughout Concord on horseback to preach to as many people as possible.

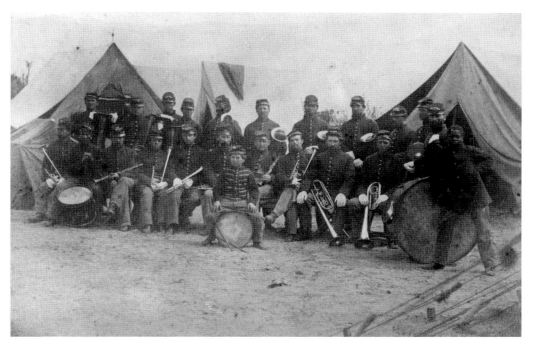

Nathaniel Marcel Gove
At age 13, Gove (b. 1849) joined the 3rd New Hampshire Regiment Band, which marched on South Carolina during the Civil War in 1862. While it was common to send a band into war zones to play soothing music to the soldiers at night, Gove, a drummer, was exceptionally young and played with his father, also in the band. The band has ties to Concord's present-day Nevers' Band. (Courtesy Giles family.)

Jacob Patterson, Civil War General
A Civil War hero who witnessed the horrors of the battlefield, Patterson entered the military as a private in the 2nd New Hampshire Infantry. He singularly recruited many soldiers before leaving to serve. He rose through the ranks and was promoted to general before leaving the service in 1865. Patterson was a teacher in Contoocook and, in his retirement, he led the Memorial Day Parade in Concord for many years.

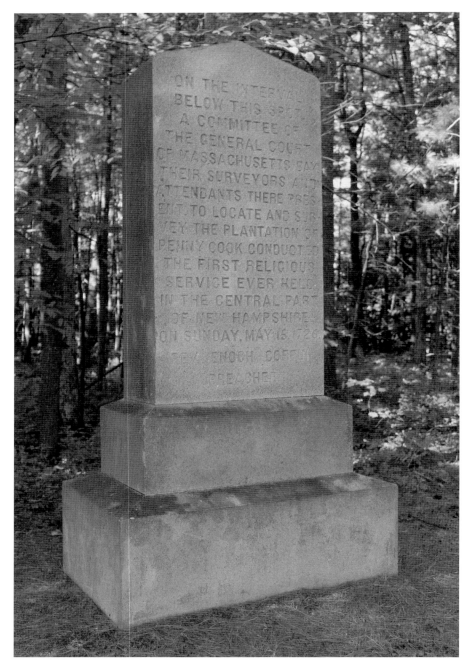

Rev. Enoch Coffin

Coffin was one of the first applicants of approximately 100 early settlers to inhabit the Plantation of Penny Cook in 1726. Upon arriving on the Sugar Ball Plain in what is now East Concord, the group of settlers camped out for the night and drew lots the next day. Coffin was the first preacher who presided over religious services for the settlers. He drew house lot No. 36, a 1.5-acre parcel on South Main Street and seven acres on the "Great Plain." He only lived a short while, dying at the age of 32.

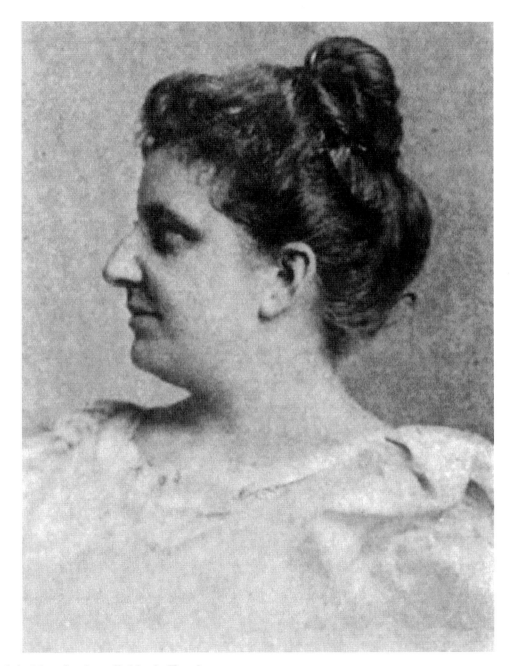

Ada Mae Aspinwall, Music Teacher

Aspinwall graduated from Concord public schools and trained at the New England Conservatory of Music as a pianist. She was the first teacher in Concord to form a business for the "Progressive Series of Piano Lessons." Aspinwall was intimately connected to music in the city, playing at the First Universalist Church as an organist for 25 years and in the Concord Choral Union as a pianist, and she appeared in many other musical productions and festivals. She was a member of the Women's Club, Concord Music Club, and Daughters of the American Revolution.

Paul T. Giles, Nevers' Band Director

Paul Giles, a clarinetist, was the band director for the Nevers' Band for 25 years. Here, the group presents a plaque to the City of Concord in recognition of Concord's continuing support of "live music" through summer band concerts. Shown here are, from left to right, Amasa Tracy, Melvin Whitcomb, Bob Hall, John Penny (city recreation director), Mayor Charles Johnson, Paul Giles, and George West, a French horn player with the band for over 65 years. The band's roots date to the Civil War era. (Courtesy Giles family.)

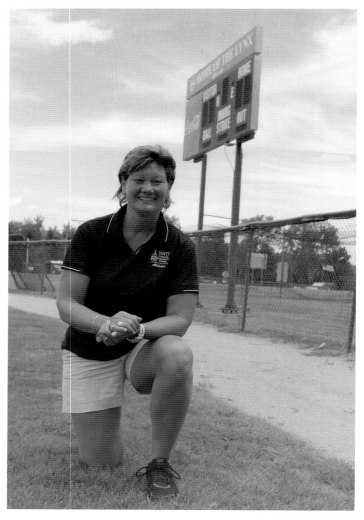

Deb Smith, Hall of Famer

With a long history in women's sports, Smith was inducted into the Ithaca College Hall of Fame for softball and field hockey in 2006. The hall honors those persons who have made an outstanding contribution to intercollegiate athletic programs and bring distinction, honor, and excellence to Ithaca College. Her coaching philosophy is to have fun and be competitive, learn the fundamentals of the game, and control the controllables, like attitude and effort.

Smith, director of recreational wellness at New Hampshire Technical Institute, has spent 18 years coaching women's softball at NHTI. She credits her success to coaches and mentors at the high school and college level who showed her how to play. She has seen the program mature from a regional, small-college conference to the national level in a few short years. The program continues to grow and expand under her leadership. The team plays more games and produces better records, which leads to longer seasons, more awards, and invitations to play against bigger schools. In 2011, NHTI had four Academic All-Americans in softball.

The longest game Smith had to coach was a Class L semifinal round against Timberlane that turned into a 26-inning matchup that lasted two days. Experiencing the intensity of a mentally and physically draining three days, NHTI won 2-1, playing 14 innings the first day and 12 innings two days later.

CHAPTER FOUR

Infrastructure

This chapter is about people who contribute to urban development and improve the standard of living for citizens. In Concord, residents live as individuals, but they work together as a legion of volunteers to accomplish what may be seen as insurmountable goals. When the Friendly Kitchen experienced a devastating fire at its location on Montgomery Street, no one thought it could bounce back. But, through the leadership of Hope Butterworth, the community responded, and an outpouring of support resulted in the building of a brand-new facility. After a few snowmobiling accidents on the Contoocook River, Dave Murray stepped up with a group of volunteers to build a bridge across the river so riders did not have to cross the thin ice in the winter. Then there is Carol Bagan, who coordinates all the events and volunteers at the Concord City Auditorium (the Audi), records and keeps the history, and does fundraising for Audi improvements.

The legends in this chapter have gone above and beyond the expected to help others in need. They have put their customers and clients first to be sure they are well taken care of and that their needs have been met. How they do it varies, but, in the end, their cumulative effort leaves Concord with improved living conditions. Everyone can benefit from that as Concord heads toward its tricentennial.

Linda Hutton, Broker

That soft Southern drawl gives away the native Texan, but Linda Hutton has been in the Concord area for over 32 years and has sold real estate for most of that time. She has sold more houses in Bow than any other realtor, representing both buyers and sellers. Her total sales in Merrimack County have reached $100 million. However, Hutton also tells clients when they should not buy a house. A client of hers fell in love with a house, but Hutton recommended she not purchase it, since it had too many problems. The woman found another house, married, and raised her two children there. Hutton also used her Texan know-how to help a couple looking at an old house in Loudon that had a hand pump. The client could not get it to work, but Hutton stepped up and created the necessary vacuum to get the water flowing. She gives back to the community by serving on three state committees that directly impact property owners. She is an accredited staging professional. She supports local schools through sponsoring contests and golf tournaments.

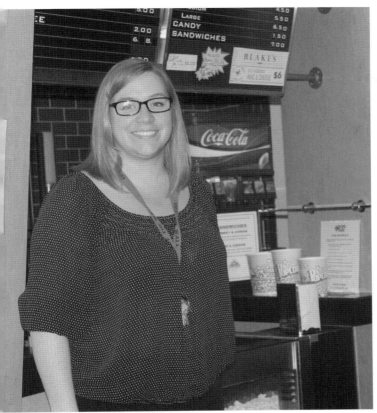

Shelly Hudson

After a stringent interview process, Hudson landed her dream job in 2010 and jumped in with both feet. Running the award-winning nonprofit Red River Theatre keeps her very busy. Hudson, a theater arts major, juggles 180 films, 65 panel discussions, special events, and partnering with other organizations for fundraisers as part of her job. Born in Concord, she was part of the 2011 Leadership New Hampshire graduating class and sits on the Creative Concord board. Red River Theatre is Greater Concord's only independent art house cinema. The venue can fully explore its mission to present film and the discussion of film as a way to entertain, broaden horizons, and deepen appreciation of life for audiences of all ages.

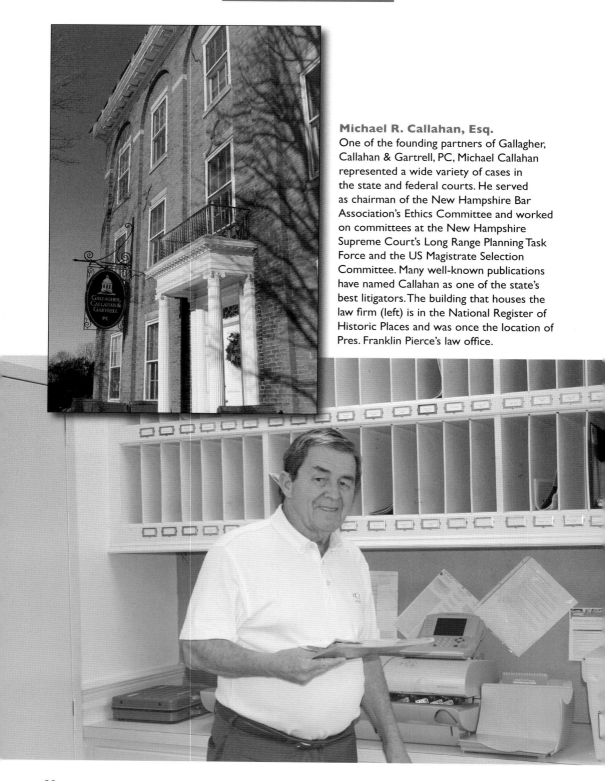

Michael R. Callahan, Esq.
One of the founding partners of Gallagher, Callahan & Gartrell, PC, Michael Callahan represented a wide variety of cases in the state and federal courts. He served as chairman of the New Hampshire Bar Association's Ethics Committee and worked on committees at the New Hampshire Supreme Court's Long Range Planning Task Force and the US Magistrate Selection Committee. Many well-known publications have named Callahan as one of the state's best litigators. The building that houses the law firm (left) is in the National Register of Historic Places and was once the location of Pres. Franklin Pierce's law office.

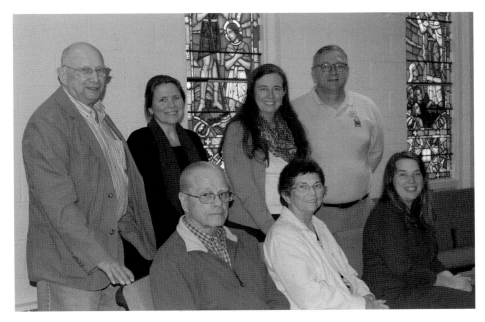

Peter Hey, Pastor

Wesley United Methodist Church is the combination of two churches that moved in 1960 to Clinton Street. They have strong music and children's ministries. Rev. Peter Hey has been the lead pastor for nine years, and his theologically progressive approach is one of openness and affirmation. His main emphasis is inclusivity of LGBT residents and advocacy throughout the denomination. People describe him as fun, approachable, and enthusiastic. Every summer, the church throws a Fourth of July picnic for all who want to attend. Shown in the above photograph are, from left to right, (seated) William Broadrick, Jane Broadrick, and Sara Lutz Blackburn; (standing) Jim Varrill, Deborah Venator, Misty Griffith, and Pastor Peter Hey.

Hope Zanes Butterworth, the Friendly Kitchen

If ever there was a driving force behind an organization's success, Hope Butterworth would be the little engine that could. Early in 1999, board president Butterworth rallied for the purchase of a building on Montgomery Street to expand the services of the Friendly Kitchen, which had been operating in a small building for 20 years. Once the building was purchased, the Friendly Kitchen began serving dinner seven days a week and added weekend breakfasts in the new location. In 2011, a fire destroyed the house. Thanks to immense efforts by a community of devoted volunteers, meals continued to be served through the kitchens of local churches while staff planned what to do next.

But then there was Hope, everywhere, and the fundraising began. Her image appeared in store windows, in local downtown shops, on bulletin boards, and in community message centers. She had a plea for help. Donations started pouring in, the fund grew, and the message spread. People in the community came together. Land was available to build a facility that could feed hundreds of people. The new building was erected at 2 South Commercial Street and opened in December 2012. There is a new professional kitchen and workspace, a large shelving area for donated food, and an expansive seating area. More than 60 volunteer groups prepare, cook, and serve the food on their designated night. The new building is a testament to the fact that, when people are down on their luck, there is Hope.

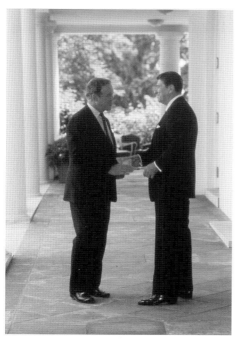

Warren Rudman, US Senator

Here, Pres. Ronald Reagan (right) speaks at the White House with Republican senator Warren Rudman in 1987. Rudman's skills as an amateur boxer helped him win battles in the Senate, and he was an advocate for fiscal responsibility in government. He helped pass two laws that mandated the government not to overspend. In February 2001, Rudman, in conjunction with others, predicted an attack on American soil within the next 25 years. (Courtesy LOC.)

James and Maura Carroll

If there is one thing the Carrolls have in common, it is taking care of people. James Carroll was a city councilor for 11 years and a state representative for two years. He owned a BMW motorcycle shop for 14 years; his heart is in customer service. Maura devoted her life to public service and worked for 25 years at Local Government Center as a staff attorney, department head, and executive director.

Juliana Eades, Community Loan Fund

Juliana Eades of Canterbury has served as executive director of the New Hampshire Community Loan Fund (NHCLF) since its founding in January 1984. *MONEY* magazine named her a 2014 *MONEY* Hero in its July edition for "creative and extraordinary work" through developing affordable home loans for low-income people. She was the recipient, in 2012, of the fifth annual Ned Gramlich Award for Responsible Finance in honor of her three decades of work creating opportunities for disadvantaged people and communities in New Hampshire. She also received *New Hampshire Business Review*'s 2013 Outstanding Women in Business Award and Centrix Bank's C-Beyond Award for "a woman who exemplifies the entrepreneurial spirit with a forward-thinking mindset." The nonprofit she helped launch, the NHCLF, has received the highest honor given to community development financial institutions (CDFI), the NEXT Award for Opportunity Finance from the Opportunity Finance Network. It has also received the Corporation for Enterprise Development's Future of Economic Opportunity Award. Previous awards and honors include the 2005 Wachovia CDFI Excellence Award for Innovation; National Community Capital Association's Award for Excellence in Financial Performance; the Federal Home Loan Bank's Community Partnership Award; the New Hampshire Corporate Fund's Dunfey Award for Excellence in Management; and the National Environmental Education & Training Foundation's National Environmental Education Achievement Award. Eades received an honorary doctorate of humane letters from Franklin Pierce College, and she was awarded the prestigious Granite State Award by UNH. She was honored as the 2008 President's Outstanding Woman of New Hampshire by Keene State College and received the 2011 Horace Mann Spirit of Service Citizen's Award from Antioch University New England.

She is a 1994 graduate of Leadership New Hampshire, has served on the board of directors of the New Hampshire Charitable Foundation, and was a founding board member of the Opportunity Finance Network, the national network of community development financial institutions. She is a member of the advisory board of the Carsey Institute's Financial Innovations Roundtable. Eades received her bachelor of arts in history from Swarthmore College and her master's of business administration from the Whittemore School of Business and Economics at UNH. (Courtesy NHCLF.)

John Tobin, Legal Advisor
Tobin served 38 years with New Hampshire Legal Assistance. When he arrived, it was a small office without much lobbying power. Over the years, he has seen it mature into an organization that lobbies for the rights of citizens. Tobin recently retired as executive director, but he stays active in legal affairs.

John Williams Storrs, Engineer
Educated in Concord public schools, Storrs (1858–1942) went on to study engineering with Charles Lund and worked at the Boston & Maine Railroad for 11 years. He started a private bridge-engineering business and wrote an illustrated guide to constructing short-span bridges. He designed the Sewall's Falls Bridge and was the first state highway engineer for New Hampshire, serving from 1903 to 1905. Storrs served as mayor of Concord from 1933 to 1942.

Samuel Coffin Eastman, Leader

The descendant of Ebenezer Eastman, Samuel (1837–1917) became actively involved in state politics and business. Eastman traveled extensively in Europe and wrote about his journeys. He was Speaker of the House in New Hampshire, school board member, and bank president. These duties earned him recognition as one of Concord's most influential leaders in 1915, the 150th anniversary of the city.

Dave and Helen Murray
The Murray family has been farming for more than 100 years. They started with delivering milk and soon branched out to poultry; up to 60,000 chicks were hatched each week. In 1964, Helen (right) and her husband, Jesse, started the greenhouse; at the age of 94, she still operates the cash register. Dave (left), the owner, works long hours every day. One of his proudest accomplishments is the bridge he lobbied the city to install over the Contoocook River. While bridges have been in New Hampshire since 1792, Dave decided that one more was necessary for the safety of all. The Hero's Bridge (below), originally in Idaho, was installed in 2008. Dave Murray raised the money, gathered permits, donated materials, and negotiated successfully with the city for the bridge.

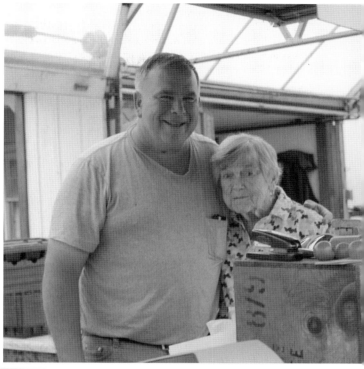

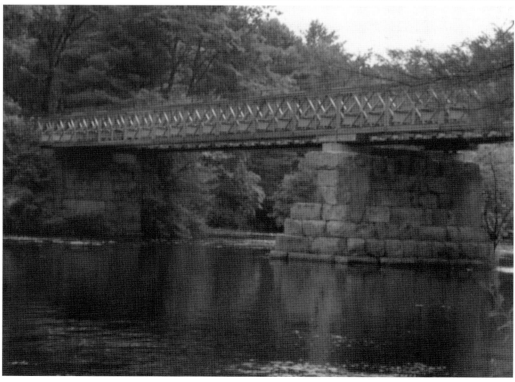

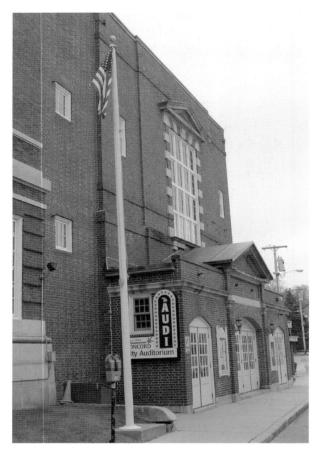

Carol Bagan, Friends of the Audi

The Concord City Auditorium has been the home of Concord's community-based arts and entertainment for 110 years, with an estimated turnstile count of 75,000 annually and open doors about 100 days each year. It has been the home of the Timothy and Abigail B. Walker Lecture Fund series since 1904, of the Community Players of Concord since 1927, of the Concord Community Concert Association since 1930, of Concord's large dancing school community since 1944 (over 2,500 young dancers from 13 companies perform on the stage every year), and of the Festival of Barbershop Harmony since 1959. Through two world wars and the Great Depression, the Concord City Auditorium remained a community-building center in the everyday life of the citizens. An ill-considered plan to destroy the theater space and turn it into city office facilities was revealed in May 1991. Arts and entertainment groups of Concord, along with social service organizations, considered the Concord City Auditorium to be their home, and they mobilized to preserve it. In short order, hundreds of people came together as the Friends of the Concord City Auditorium, a nonprofit, all-volunteer organization with a specific mission: to preserve and maintain the historic municipal stage and to foster its affordable and accessible use for the benefit of all the people of the community. Since 1991, the group has raised and invested well over $1 million in upgrades to the theater, bringing it up to top code and in line with stagecraft standards. The group has no paid staff, no administrative expenses, and no development director, and it undertakes no feasibility studies. Carol Bagan and the Friends of the Concord City Auditorium work in a close partnership with city staff to assist the smooth operation and continuing improvement of the theater. The Concord City Auditorium has been honored by the American Public Works Association and the New England Theatre Conference, among others, as a shining example of a city-citizen partnership.

Kathi Guay, Register of Deeds

Elected a remarkable 15 times to the office of the Registry of Deeds for Merrimack County, Kathi Guay started as a part-time clerk recording documents in September 1975 and was hired full-time shortly thereafter. First elected in 1984, she has been reelected every two years since then. The registry has undergone an extensive transformation under her leadership. Manual, handwritten documents and recordings have been replaced by computer technology, online services have been established, and a database now handles the thousands of records that must be filed whenever a transaction such as the sale of a property, foreclosure, or tax delinquency is recorded. To keep up with all the changes, Guay has professional certifications in land records administration and records management, and she has served as president of the New Hampshire Register of Deeds Association (NHRDA) and as president of the National Association of County Recorders, Election Officials, and Clerks (NACRC). Currently, she is an executive committee member of the New Hampshire Association of Counties and a board member and committee cochair of the Property Records Industry Association. She is also certification committee chair of the NACRC. Guay also serves as the chair of the legislative committee for NHRDA. The Registry of Deeds is also tasked with ensuring, with pinpoint accuracy, that all documents meet recording standards set by the State of New Hampshire; collecting appropriate fees on all documents; and ensuring the electronic capture, reproduction, and permanent record of every document passing through the registry before being returned to its owner. Of the 10 counties in New Hampshire, Merrimack County and Guay was the first to establish access to land records on the Internet and the first to implement electronic recording.

Elizabeth Hager, Public Servant

Elizabeth Sears Hager was in public service for almost three decades. She was first elected to the New Hampshire Legislature in 1972 and served for 13 terms before being defeated in the Republican primary in 2008. She ran for the Republican nomination for governor in the September 1992 primary election. Hager was also a Concord city councilor, serving as the city's first—and, to this day, the only—female mayor (1988–1990). Hager was a delegate to the 1974 and 1984 Constitutional Conventions and was a sponsor of the Equal Rights Amendment, which became a part of the State Constitution in 1975. Hager was executive director of the United Way of Merrimack County in Concord for 15 years and retired as executive vice president of Granite United Way. She assumed those positions after years of volunteerism, including roles as both president of the board and campaign chair of the Concord United Way. Hager has also served on the board of directors of many organizations. She is currently a founding board member of the New Hampshire Fiscal Policy Institute and a member of the Squam Lakes Natural Science Center Board. She is also a director of Lincoln Financial Variable Insurance Products Trust. Elizabeth Hager earned a master's degree from UNH after receiving an undergraduate degree from Wellesley College. She and her husband, Dennis Hager, have two married daughters and four grandchildren.

CHAPTER FIVE

Communications

The people in this chapter represent pioneers in the way they have communicated their message. Indeed, Concord has seen its share of renowned orators. Whether by written or spoken word, or by the clicking of the telegraph, feeling is conveyed in the message. By being the First in the Nation state, virtually every candidate who seeks the presidential nomination has traveled to Concord. And all of the Democratic candidates have ended up in the living room of Mary Louise Hancock. Governors seek her advice when running in an election, and she freely gives it.

Readers will learn about Samuel F.B. Morse, an artist who studied in Europe. His travels brought him to Concord before he invented the telegraph and Morse code. Computer technology has him to thank for laying the groundwork for future communications discoveries.

Kristina Rieger, an outstanding young athlete, communicates with new college students to help them adjust to their first year away from home. She excels at two sports and academics.

In 1812, Daniel Webster's speech in Washington, DC, condemned the War of 1812 and solidified his career as an orator and statesman. He was highly respected by the courts, and many justices used Webster's legal briefs to model their decisions.

These are just a few of the people who have helped shape this city using their skills in communication.

Jeanne Shaheen, US Senator

Shaheen continues her fight in the US Senate, but, for six years, she worked for the citizens of New Hampshire as the state's first female elected governor (1997–2003). The New Hampshire government is the state's largest employer, with the majority of employees and buildings within Concord city limits.

Among the many milestones in her career, she signed into law a controversial bill in 1999 that renamed the state's civil rights holiday as Martin Luther King Jr. Civil Rights Day. The bill to rename the holiday was first introduced in the legislature 20 years previously, in 1979. After many defeats in both the Senate and House, along with several death threats, Governor Shaheen vowed to "not end this century without marking Martin Luther King Day part of the heritage we leave our children." Political maneuvering and a lack of support for passage of the bill kept supporters focused on reintroducing the bill many times in this Live Free or Die State. Many students from local high schools had organized marches and rallies in the months before the official passing, and they looked to Governor Shaheen to use her power to make it right.

The signing took place on the lawn of the state capitol in June 1999. In attendance were many supporters and Martin Luther King III, pictured here with the governor. The newly named holiday was observed for the first time in 2000. (Courtesy Associated Press.)

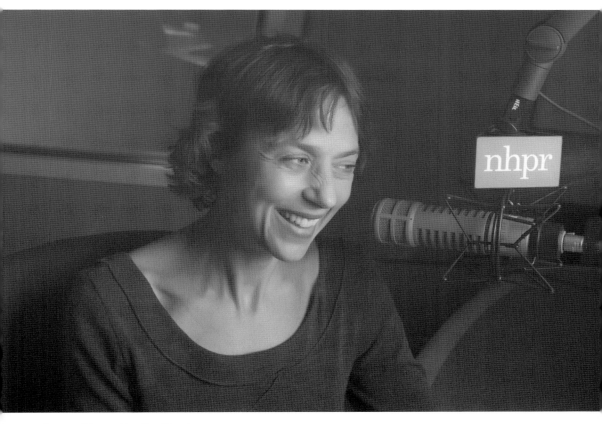

Laura Knoy, Radio Host
Knoy, the host of New Hampshire Public Radio's daily call-in program *The Exchange*, is well known in the state for her in-depth coverage of important issues, and she is widely regarded for her interviews with presidential hopefuls. Knoy, who has hosted *The Exchange* since its inception in October 1995, has become one of the most recognized and respected broadcasters in the state. In 2007, she was named New Hampshire Broadcaster of the Year by the New Hampshire Association of Broadcasters. Prior to hosting *The Exchange*, Knoy worked in public radio in Washington, DC, as a local reporter and announcer for WAMU and as a newscaster for NPR. She occasionally guest hosts national programs such as *The Diane Rehm Show* and *Here & Now*. Knoy grew up in Keene, New Hampshire, and currently resides in Concord. (Courtesy New Hampshire Public Radio.)

David H. Souter, Supreme Court Justice

Souter, a retired associate justice of the US Supreme Court, was born in Melrose, Massachusetts, on September 17, 1939. He graduated from Harvard College, from which he received his bachelor's degree. After two years as a Rhodes Scholar at Magdalen College, Oxford, he received a bachelor's in jurisprudence from Oxford University and a master of arts degree in 1989. After receiving a bachelor of law degree from Harvard Law School, he was an associate at Orr and Reno in Concord, New Hampshire, from 1966 to 1968, when he became an assistant attorney general of New Hampshire. In 1971, he became deputy attorney general and, in 1976, attorney general of New Hampshire. In 1978, he was named an associate justice of the Superior Court of New Hampshire, and he was appointed to the Supreme Court of New Hampshire as an associate justice in 1983.

Souter became a judge of the US Court of Appeals for the First Circuit on May 25, 1990. Pres. George H.W. Bush nominated him as an associate justice of the Supreme Court, and he took his seat on October 9, 1990. Justice Souter retired from the Supreme Court on June 29, 2009. (Courtesy Linda Stout.)

Priscilla Giles, Percussionist
Giles has been playing the drums since junior high school. A 1945 CHS graduate, she went on to study music at UNH, where she met Paul, a music teacher and her future husband. She is the band's official music librarian and serves on the scholarship committee. Giles has played percussion for the Nevers' Band for 62 years. (Courtesy Giles family.)

James Langley,
Newspaper Editor
Appointed by President Eisenhower to the role of US ambassador to Pakistan, Langley (left) was also the longtime *Concord Daily Monitor* editor-in-chief. In 1967, Langley played an important role in the impeachment of Mayor J. Herbert Quinn. Langley had been critical of the mayor in several editorials, and the mayor ordered the police to arrest Langley as he left a drinking establishment for driving while intoxicated. Quinn was later impeached for executing the sting operation. (Courtesy Associated Press.)

Judy Fortin, Reporter and Cancer Institute Director
Fortin is director of communications and media relations for the Winship Cancer Institute of Emory University in Atlanta, Georgia. From 2011 to 2013, she served as national director of media relations for the American Cancer Society. Fortin, born in Hanover, New Hampshire, graduated from Concord High School in 1979 and attended Bowdoin College. She earned bachelor degrees in government and French in 1983. Fortin began her broadcast career in Plymouth, New Hampshire, where she started out as an announcer and then news director at WPNH AM/FM radio. From January 1986 to June 1989, she was a weekend anchor and general assignment reporter for WMUR-TV in Manchester, New Hampshire. Prior to joining CNN, Fortin worked as a general assignment reporter for WCVB-TV in Boston. From 1990 to 2006, she anchored *CNN Headline News*. She also served as a national correspondent for CNN Newsource, a news service used by local affiliate stations. In 2006, Fortin became a correspondent for the award-winning CNN Medical Unit. She received an Excellence in Media Award in 2009 from the National Donor Marrow Program and, in 2008, a MORE Award for reporting excellence from the American Academy of Orthopaedic Surgeons. She is the recipient of a national Emmy Award for CNN group coverage of the Oklahoma City bombing in 1995. Fortin is married with two children. (Courtesy Judy Fortin.)

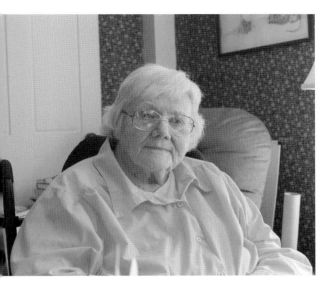 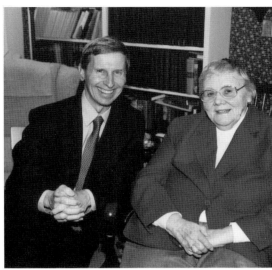

Mary Louise Hancock, Pioneer

A legend in Concord and beyond, Hancock has had a long and distinguished career as a politician. She has worked as a political consultant to many Democrats, including Bill Clinton and John Lynch. She has been called the "Grand Dame" and "Queen Bee" of New Hampshire politics. Virtually every Democratic candidate for president has visited her home, which was called the "pre-eminent political salon" by The Economist. In the 1940s, Hancock worked in the state planning department and was promoted to director, a rare occurrence for a woman in New Hampshire at the time. She was a pioneer during her 16 years in the office, striving to prevent uncontrolled growth and laying the groundwork for communities to create planning boards and implement zoning ordinances. Her office worked to highlight the connection between land use and water quality. After she retired in 1976, Hancock ran for the state senate and won, serving as the first woman to represent Concord's District 15. She served as a trustee of the University System of New Hampshire and was a Concord School Board member from 1955 to 1964. Hancock worked tirelessly to advance equal pay for women in the district and has been awarded the YMCA's Susan B. Anthony Award for her commitment to feminist ideals. Other awards for outstanding contributions include an honorary degree from Notre Dame College, the New Hampshire Hadassah Citizen's Award, the Distinguished Service Award from the American Institute of Planners, and the Meritorious Service Award and Medal from the UNH Alumni Association. She has slept in the White House, having been invited by President and Mrs. Jimmy Carter. She remains active in local, state, and national politics. (Right, courtesy Mary Louise Hancock.)

John Gilbert Winant, Ambassador
Republican governor for three terms, Winant (1889–1947) was the first head of the Social Security Administration and US ambassador to Great Britain. He made great strides while there for US–Great Britain relations. His failed marriage and affair with Winston Churchill's daughter Sarah led him to commit suicide in 1947. (Courtesy LOC.)

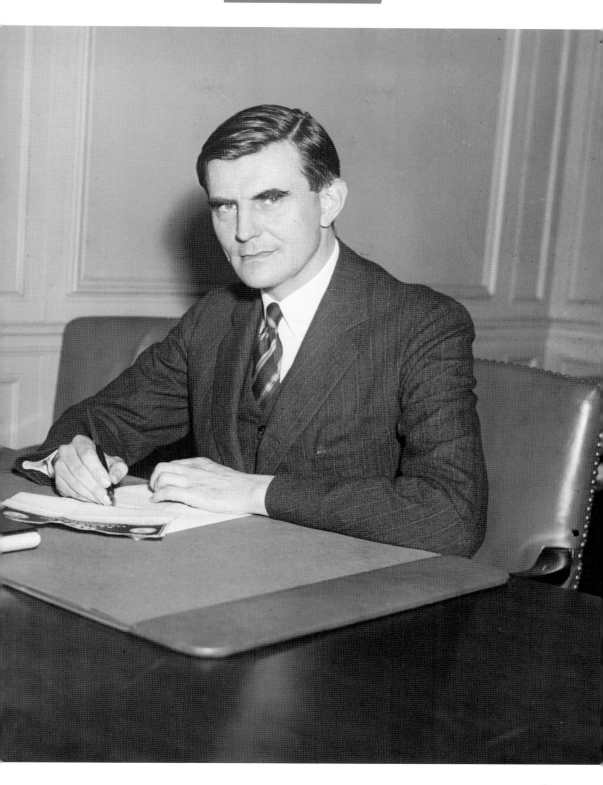

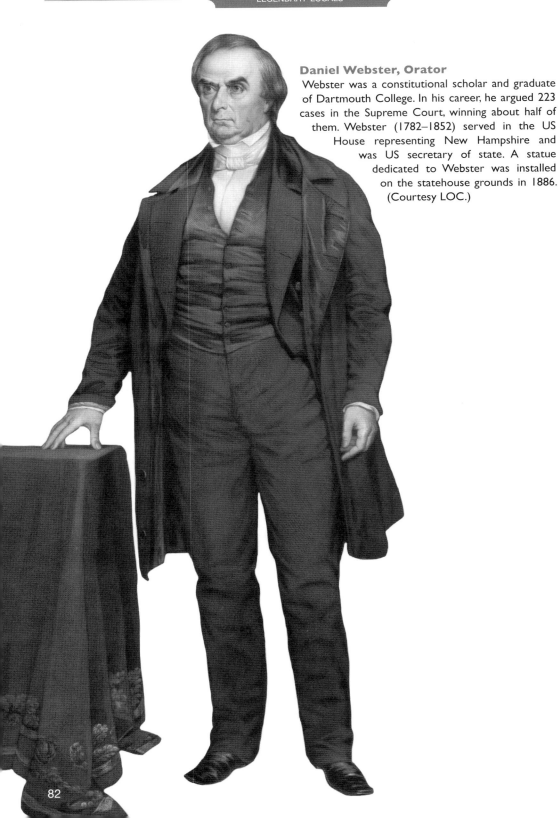

Daniel Webster, Orator

Webster was a constitutional scholar and graduate of Dartmouth College. In his career, he argued 223 cases in the Supreme Court, winning about half of them. Webster (1782–1852) served in the US House representing New Hampshire and was US secretary of state. A statue dedicated to Webster was installed on the statehouse grounds in 1886. (Courtesy LOC.)

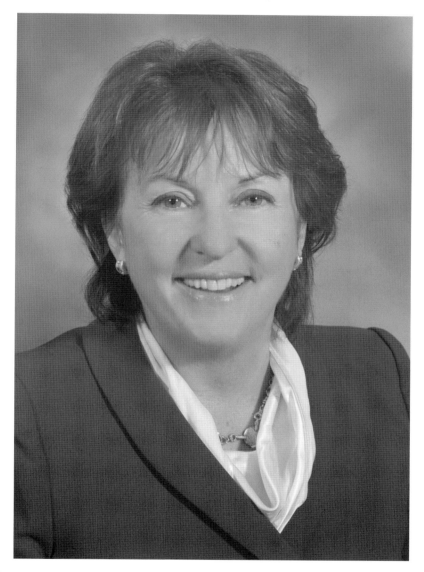

Sylvia Larsen

Larsen was a councilor-at-large from 1989 to 1998. In that capacity, she was a member of the economic development, the solid waste, and the fiscal goals committees, and she was chairwoman of the community development advisory committee. Larsen served her 10th term representing District 15, which includes the state's capital city of Concord, along with Henniker, Hopkinton, and Warner. From 2006 to 2010, she was senate president. Her legislative priorities include funding education, including higher education; promoting job growth; expanding workforce housing; establishing affordable health care; safeguarding the environment; and advancing property tax relief. For the 2013–2014 session, she was the vice chairperson of the capital budget committee and was also a member of the senate finance and joint fiscal committees. Larsen was instrumental in the passage of a law guaranteeing equal pay for equal work. She is proud that "New Hampshire is sending a crystal clear message that the State of New Hampshire is on the side of all workers guaranteeing a fair and equal paycheck, without fear of retaliation." After serving 20 years in the senate, she announced her retirement in 2014. (Courtesy New Hampshire State Senate.)

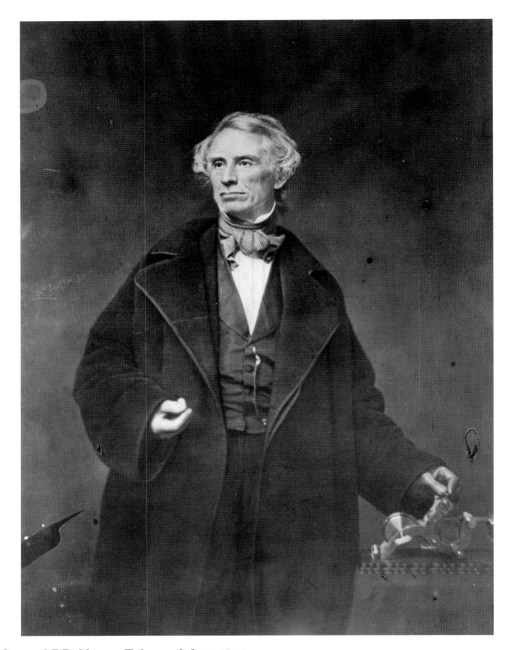

Samuel F.B. Morse, Telegraph Inventor

No invention has provided the foundation of communications as much as the telegraph. Morse (1791–1872) was an artist and painter in his early years and perfected his skills in England. In 1816, he found himself in Concord and, two years later, married Lucretia Pickering, only 16 years old. Pickering died at the age of 25 after the birth of her third child. In 1840, after studying electricity through a series of tests, Morse secured a patent for the telegraph. His invention was famously used in 1845 by the police to capture John Tawell, who murdered his mistress and escaped to London by train. Tawell's description was telegraphed ahead by local authorities, and the police nabbed him as he departed from the train.

Edward H. Rollins, Senator and Banker

Rollins was a businessman and a prominent figure in politics. He served three terms in the US Congress and was in the US Senate for six years. Rollins (1824–1889) was founder of the First National Bank of Concord and owned the investment house E.H. Rollins & Sons in Boston. It has been said that the Republican Party in New Hampshire was started in his living room. (Courtesy LOC.)

Napoleon Bryant, Legislator and Abolitionist

Bryant was a mere 14 year old when he assumed full responsibility for his financial support and education. He worked for various law firms while studying at Harvard Law School, from which he graduated in 1848. He became heavily involved in jury trials and became recognized as a successful orator against even the most experienced opponents. Bryant outmaneuvered several legislators during his speakership in 1859, illustrating his bravery and political fortitude. He tested the constitutionality of several laws and hotly debated states' rights in several areas. An ardent abolitionist, Bryant gave many stump speeches throughout the state in support of a free nation.

Kristina Rieger, Athlete and Academic
Although only in her late 20s, Kristina Rieger has accomplished more than most people do in a lifetime. Bringing home Concord High's first volleyball championship in 2005 was the beginning of a history of excelling in sports. She matriculated to NHTI, where she was an honors student and an outstanding two-sport success. She received many honors as the softball team captain and was recognized as an all-academic in volleyball. And, if that were not enough, Rieger went on to Daniel Webster College to finish her bachelor of science degree in sports management with a grade point average of 4.0 and received numerous outstanding female scholar and athletic awards. She was named WMUR-TV Hometown Hero in March 2010. Rieger earned her master's degree in sports management from Southern New Hampshire University, where she currently teaches, tutors, and helps new students transition to college life. And, of course, she plays on local softball and volleyball teams. (Courtesy Kristina Rieger.)

Henry French Hollis, US Senator

Educated in the Concord school system and graduating in 1886, Hollis (1869–1949) went on to study law at Harvard College, graduating with high honors in 1892. After unsuccessfully running for the New Hampshire Legislature and against Chester Jordan for governor, Hollis was elected to the US Senate in 1913. He was the first Democrat elected to the position in 61 years.

CHAPTER SIX

Back Roads

The people in this chapter work tirelessly for what they believe in. They pursue their passion day after day without the promise of awards or recognition. Among these people are those to whom residents look for inspiration during difficult times, long cold winters, or hot summer days. It is comforting to know that others have been challenged and to hear their stories.

Steve DeMasco grew up in Spanish Harlem and was tempted by gangs to become a member. But, with his mother as inspiration, Steve turned his life around. He now helps kids in similar situations.

Captured by Native Americans, their lives threatened, Hannah Dustin and a couple of people from her community escaped from the island where they were being held and returned with the scalps of several of their captors. Bravery in the face of adversity got them back safely to where they belonged.

During World War II, Barbara Webber and a team of women proudly stepped up to help cut millions of board feet of lumber that was downed in the 1938 hurricane. They felt a duty to their country, completing the mission in one year's time. They quietly went back to their homes when the men returned from war. Hardly anyone knew what an accomplishment they achieved, because none of the ladies involved ever talked about it.

Readers will learn about the courage and strength these women and men exhibited when challenged.

 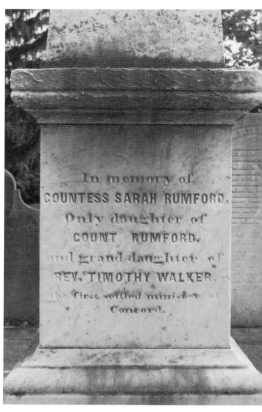

In memory of
COUNTESS SARAH RUMFORD.
Only daughter of
COUNT RUMFORD,
and grand-daughter of
REV. TIMOTHY WALKER,
the first settled minister of
Concord.

Sarah Rumford, Countess

Rumford, a world traveler, was the first American to have the title of countess. According to Nathaniel Bouton's history, her mother, Sarah Rolfe, was a rich and well-connected heiress 13 years older than her husband, Benjamin Thompson. He was sympathetic to the British during the American Revolution and lived in England. After her mother's death, Rumford (1774–1852) went to England to live, but she returned to Concord in 1845 with her adopted daughter, living in luxury for the remainder of her life. Thompson established the Rolfe and Rumford Asylums. Sarah Rumford left her fortune to organizations for needy children, motherless girls, widows, and the mentally ill.

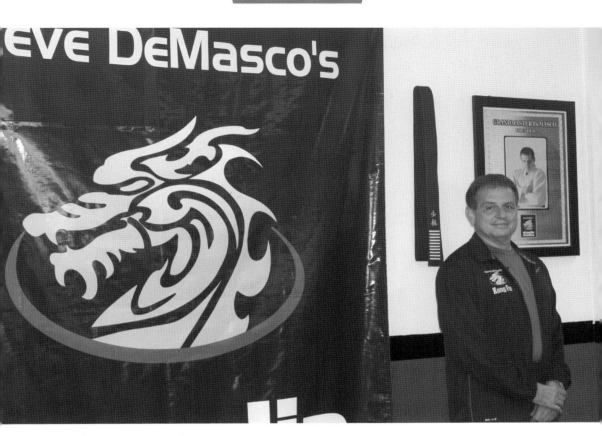

Steve DeMasco, Grandmaster

DeMasco grew up in the tough New York City neighborhood of Spanish Harlem. His mother had an eighth-grade education, and everything about his upbringing seemed to indicate that he would grow up on the wrong side of the tracks. But DeMasco saw he had a choice, as well as the drive and ambition to change his destiny. He studied kung fu in Chinatown in Boston for 14 years and took private lessons in China for 17 years. He is the only non-Asian allowed to train with the Shaolin monks. DeMasco, a 10th-degree black belt, has opened 150 schools and trained thousands of youngsters in Shaolin kung fu. Grandmaster DeMasco has done pro bono work with the FBI for 15 years, organizing violence-prevention conferences and teaching law enforcement officials and school administrators about ways to stop bullying.

Hannah Dustin
Dustin (1657–1736) was the subject of a chilling story of captivity and heroism. She was captured by Native Americans in the 1600s. The mother of nine children, she and her youngest were taken during the Raid on Haverhill (1697), when 27 colonists were killed. After six weeks and with the help of other captives, she escaped after killing and scalping several of her kidnappers. She is the first woman in the United States to be honored by a monument, erected on an island off US Route 4, near where she was held captive.

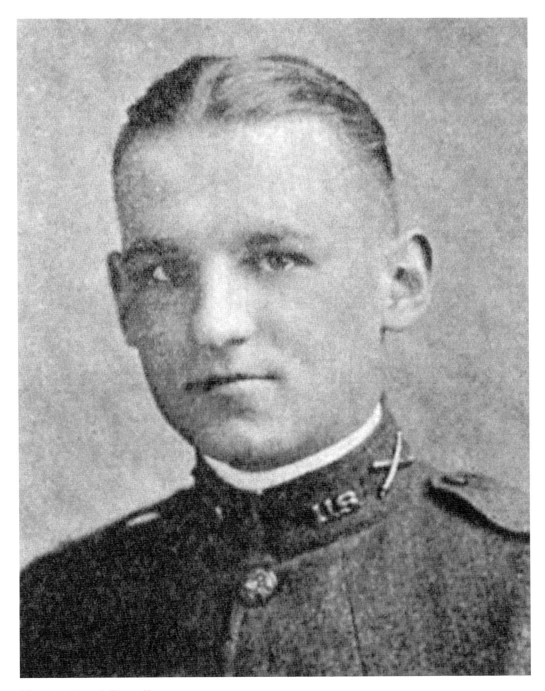

Horton Lloyd Chandler
Commissioned a second lieutenant in 1919, Chandler (1898–1970) went on to distinguished service in the military. He was the grandson of the late senator William E. Chandler, graduated from Concord High School in 1914, and was a graduate of Dartmouth College in 1918. There, he was a member of the Sigma Chi fraternity.

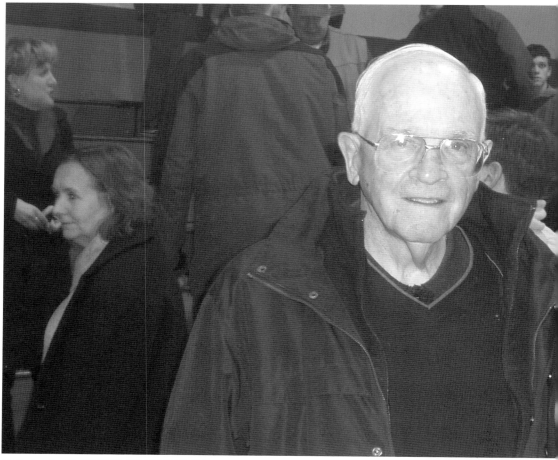

**Tom Hardiman
and Frank Alosa**

At 85 years old, Hardiman is probably Concord's best ever three-sport high school athlete. He was born in Concord and has lived here his entire life. He played two sports at Georgetown University, football and basketball, and was inducted into the school's hall of fame for both. After Georgetown, Hardiman played briefly for the Chicago Bears in the preseason before he was drafted into the US Army. He is known in Concord as an athlete, coach, businessman, and gentleman. Hardiman was the first inductee to the Concord Catholic High Schools Athletic Hall of Fame. In 2010, the Bishop Brady gymnasium was named the Thomas M. Hardiman Gymnasium in his honor. In the above photograph, Hardiman (left) and Frank Alosa pose in the gymnasium in December 2012.

Alosa was the star player on Tom Hardiman's 1963–1964 Bishop Brady basketball team. Bishop Brady opened as a new school in September 1963 (formerly St. John's High School), winning the Class I State Basketball Tournament in its first season, with Hardiman as coach and Alosa as the high scorer. Hardiman had coached St. John's team the previous nine years but only coached that first year at Brady. The school won the championship the next two years as well, with the late Frank Monahan as coach and Alosa on the team. Frank Alosa has coached Bishop Brady basketball and Trinity High School teams. He runs the Granite State Raiders Amateur Athletic Union basketball program, which produces the best basketball players in the state. Frank's son Matt, also a high school and college basketball star, now coaches Pembroke Academy basketball. Frank Alosa and Tom Hardiman are best friends and talk to each other almost daily. (Above, courtesy Bill Hardiman.)

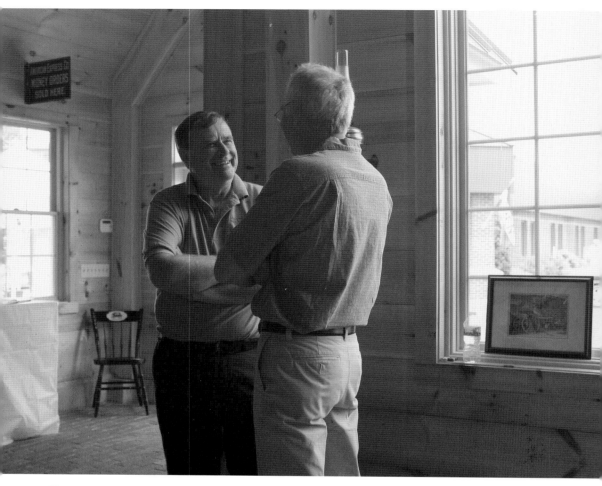

Tom Prescott, Johnny Prescott Oil Company
A family-owned and -operated oil company since 1940, the business was handed down from Johnny, the father of Tom Prescott (above, left). The Prescott family has been in business since the 1800s, when they supplied water to the Concord Heights through dug wells and underground wooden pipes. Back then, there were only 65 households in the area. Johnny Prescott Oil Company is a strong supporter of breast cancer research and sponsors walks to raise money.

Maria F. Putnam, Dedicated Worker
The only female employee in a company of 400 men, Maria Putnam retired in 1895 after 30 years of service to the Abbot-Downing Company. She was given a watch and a party upon her retirement and was recognized for being a woman who could operate a sewing machine better than any man could. She was blind for the last 20 years of her life. (Courtesy Peter James.)

Barbara Webber, Sawmill Operator (ABOVE AND OPPOSITE PAGE)
In October 1942, on the north end of Turkey Pond, the US government built a sawmill to be operated by an all-female workforce during World War II. As a result of the 1938 hurricane, millions of board feet of lumber had to be gathered from different locations in New Hampshire and deposited in Turkey Pond. The mill was open for a year, and Barbara Webber was one of the operators. She came to work every day for this timber-salvage project, which involved about a dozen other women, processing the lumber into usable planks. In the above photograph, Webber (right) and Violet Storey send a plank down the conveyor. (Above and opposite, courtesy LOC.)

Melissa Keeler, All-American

Born and raised in Concord and a 1998 graduate of Concord High School, Keeler collected all-state honors in both softball and volleyball. She was a part of the 1996 championship team and the 1997 runner-up team, and she was named Class L Player of the Year in her senior year. Keeler attended NHTI from 1999 to 2001, where she played one season on the NHTI softball and volleyball teams. In 2000, Keeler won the Northern New England Small College Conference (NNESCC)/Yankee Small College Conference (YSCC) championship, earned NHTI's Athlete of the Year award, and was named a NNESCC All-American. She earned a full athletic scholarship to Southern New Hampshire University. One of the top players in the history of the program, she was a three-year member of the team (2002–2004) and led the Penmen to 49 victories and a program-record 19 wins as a senior. A two-time SNHU Female Athlete of the Year and Northeast-10 Conference all-star selection, she established the season record for wins (15), ERA (.86), and strikeouts (135) as a junior and closed out her career as the program's leader in strikeouts (300) and ERA (1.21). She also finished tied for the school record in career wins (32). Not to be overlooked, Keeler also owns a .301 career batting average. Keeler was inducted into the SNHU Hall of Fame in January 2010. After graduating, she coached the SNHU softball team for seven years. (Courtesy Melissa Keeler.)

Alice Ericson Cosgrove, Artist
Just a few months before her death in 1971, Alice Cosgrove was honored at her retirement party (pictured). Born in Concord in 1909, she attended Concord High School. Cosgrove pursued her interest in art and studied at the Museum of Fine Arts in Boston for four years. She designed the New Hampshire Marine Memorial at Hampton Beach, which was dedicated on Memorial Day 1957. Other projects included murals, maps, covers, and posters for state publications. (Courtesy Milne Special Collections.)

J. Wayne Ferns, Aviator

The Concord Municipal Airport was established in 1918 with dirt runways and no hangars, until one was built in 1928. By 1946, J. Wayne Ferns, a naval aviator during World War II, opened Ferns Flying Service. Ferns (1918–1985) operated and managed the airport until 1985.

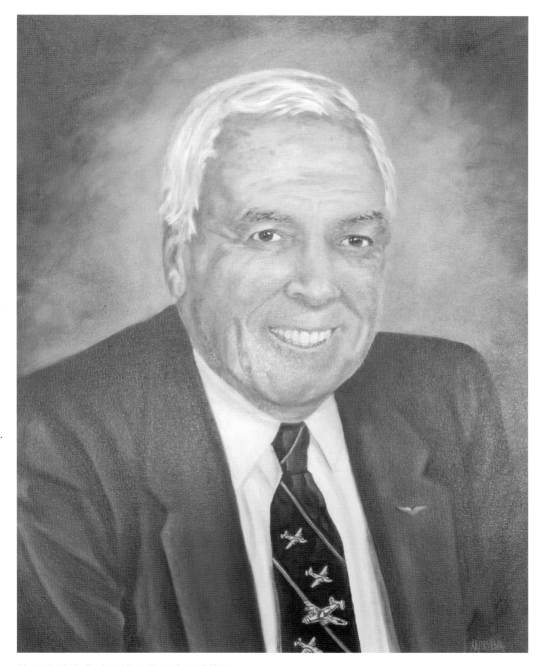

Harold W. Buker Jr., Bomber Pilot
Buker was director of aeronautics for the New Hampshire Department of Transportation from 1986 to 1996. A B-24 bomber pilot in World War II, he survived 11 months in a German prisoner-of-war camp. He made countless unselfish contributions to the community at large and to his country. The terminal (opposite, above) was renamed in his honor in 1996.

Anita O'Malley, Nurse

O'Malley remembers learning how to drive on the Kancamagus Highway when it was still a dirt road. Growing up, she knew she wanted to help others, and she became a nurse in 1968. She remembers her first day on the job and says that every day she worked was better than the previous day. O'Malley's passion was taking care of babies and their mothers at the hospital, which she did for 46 years. She worked the night shift all those years and was often the person who gave the newborns their first bath and welcomed them into the world. She is married and has three grown children. These days, O'Malley takes her dog, Maggie, on daily walks.

Susan McLane, Audubon Supporter

McLane, devoted to the New Hampshire Audubon, was a trustee and served on the board. In 2006, the Audubon renamed its existing building and new construction the McLane Center. The building is certified to high standards in green construction technology. Susan McLane will also be remembered for her public service as a senator and state representative.

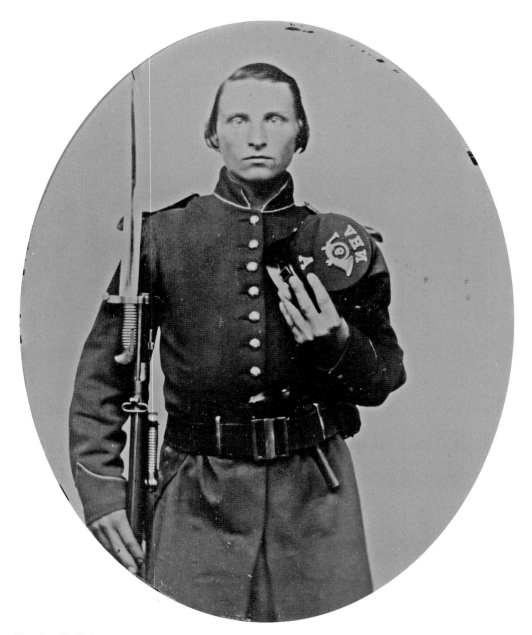

Charles Judkins

This Civil War hero from Concord sent a photograph home to his sister with the inscription, "To my sister Addie. When you see this remember me, from Charles M. Judkins, Company A, 9th NH Infantry Regiment." When Private Judkins was wounded in battle, he was transferred to Company G, 6th US Veteran Reserve Corps Infantry Regiment at Camp Colby in Concord and continued his service. The reserve corps had two battalions of soldiers who were wounded and physically disqualified to be at the front lines. The 1st Battalion was for wounded soldiers who could do light work, and the 2nd Battalion was for soldiers who lost a limb but continued to serve as nurses, cooks, and guards. (Courtesy Liljenquist Family Collection of Civil War Photographs, LOC.)

Charles Doyen
After attending Concord public schools and graduating from the US Naval Academy in 1881, Doyen was quickly promoted through the ranks of the Marine Corps. The highly decorated soldier served in all parts of the world, including Cuba, Puerto Rico, and the Philippine Islands. Attaining the rank of brigadier general in 1917, Doyen (1859–1918) was in command of the first regiment of Marines deployed to France in June 1917. The Doyen monument to his service is on Court Street.

Cathy Emerson, Animal Protector

In 1911, a group of concerned individuals started an SPCA to serve the Concord area. By the 1950s, an animal shelter was established on a farm property on Washington Street in Penacook. It would be the SPCA's home for over 60 years. In 2014, a new animal shelter (above) was built on Silk Farm Road in Concord and was named for a generous donor. Today, the Pope Memorial SPCA of Concord-Merrimack County shelters and finds places for homeless pets, provides humane education to the community, and works to prevent and investigate animal cruelty.

Cathy Emerson celebrated her 25th year with the SPCA in 2014. Much has changed in the standards of animal sheltering in that time. Emerson moved up the ranks to become the shelter's director of operations, overseeing all shelter activities. She is respected throughout the state as a leader in animal-welfare issues and shelter operations. (Right, courtesy SPCA.)

108

Abby Lange, SPCA Advocate
Lange has lived in Concord for over 40 years and joined the board of directors of the SPCA in 1999. "Things started to change in the animal sheltering world," she says, "and I wanted to encourage that change here through community education and changing people's minds about what an animal shelter is all about. That was an effort I could get behind." And get behind it she did! Now, 15 years later, Lange remains an active volunteer with the Pope Memorial SPCA. (Courtesy SPCA.)

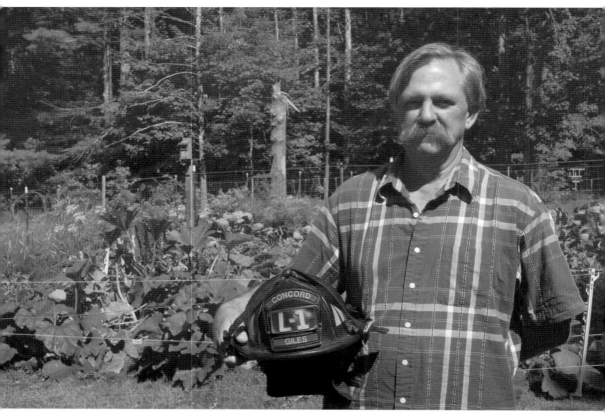

Douglas Giles, Firefighter

Not sure what he wanted to do after graduating high school, Giles enrolled in UNH for forestry, but his heart was not in it. He found his way to basic firefighting training and had a 30-year career that included training on all apparatus and conducting specialized technical rescues. He witnessed the start of the first paramedic program in the state and the establishment of a professional fire academy.

CHAPTER SEVEN

Legacy

This chapter recognizes the people who established a gift, inspired others to greatness, or left behind a memory to be appreciated by future generations.

People of a certain age will remember the space race or will have at least read about it. And that is why Concord was excited to learn that Christa McAuliffe was selected to be the first teacher in space. Since her tragic death on board the Space Shuttle *Challenger*, she continues to be an inspiration. Concord paid tribute to this magnificent teacher by building a new elementary school in her name. She will always be in the hearts and minds of the citizens of Concord.

Franklin Pierce's law office was on North Main Street, across the street from the Edward Rollins house, which burned to the ground in the 1800s and is now the site of a gas station. Pierce was president of the United States during a very controversial period in American history. The abolition of slavery was being fervently debated, and a civil war was looming.

This chapter would not be complete without a mention of Nathaniel and Armenia White. They were philanthropists who left their legacy all over the city. After her husband's death, Armenia bequeathed her land to the City of Concord for a park, with the stipulation that it would always be known as White Park. She was an amazing woman who had the foresight to leave Concord in better condition than when she was alive. Their wealth was spread to other buildings and property throughout the city. Nathaniel White considered Concord his home and cherished the city to his dying day.

In the end, Concord's legendary locals succeeded in building a community rich in diversity and welcoming to all of its citizens.

Concord Coach

Mark Twain called the Concord Coach a "Cradle on Wheels." Over 1,800 Concord Coaches were built in the South Main Street factory; two of its buildings remain standing today. The Concord Coach was an icon of the city's thriving economy and its status as a transportation hub. The 1890s depression and the rise of automobiles led to the coach's demise. In New Hampshire, 18 coaches are in existence. Concord is home to four of them: one is at the Concord Insurance Group; one is at Johnny Prescott Oil; another is at the New Hampshire History Museum; and the fourth is at the *Concord Monitor*. All of the coaches are open to the public. The fare to travel from Concord to Boston in a stagecoach in 1820 was $1. (Below, courtesy LOC.)

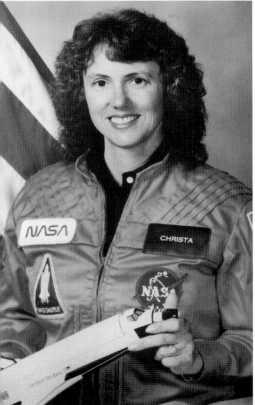

S. Christa McAuliffe, First Teacher in Space

McAuliffe was born on September 2, 1948, in Boston, Massachusetts. She graduated from Framingham State College in 1970 and embarked on a teaching career that would lead her to Concord High School in 1982. If there were ever an example of an entire city rallying around a tragedy, it would be the day that Christa McAuliffe perished in the Space Shuttle *Challenger* explosion. Every citizen can remember exactly what he or she was doing on January 28, 1986.

McAuliffe, an enthusiastic social studies teacher at Concord High School, trained for the mission with dedication and conviction. She had a love for space and was selected by NASA from over 11,000 applicants to be the first teacher in space. She achieved celebrity when she appeared on *Good Morning America* and the *Today Show* before training began. McAuliffe left behind a husband, Steve, and two children. She is sorely missed by all in the community. Most recently, her memory was honored when the City of Concord built the McAuliffe Elementary School on North Spring Street. McAuliffe was posthumously awarded the Congressional Space Medal of Honor in 2004 by Pres. George W. Bush. (Left, courtesy NASA.)

Douglas N. Everett, Olympic Star
Everett (1905–1996) competed in the 1932 Olympics at Lake Placid, New York. He worked hard on his Dartmouth College team and demonstrated unique skating ability and skillful puck handling. The arena that bears his name was built in 1965 and is home to the Concord High School Crimson Tide's hockey games. (Courtesy Everett Arena.)

Charles Willey, Brave Sailor
A Navy machinist on board the USS *Memphis*, Willey (1889–1977) stayed at his post in the engine room until ordered to leave, despite the total devastation the ship was experiencing in a tsunami. For his dedication and bravery, he was awarded the Medal of Honor in 1916.

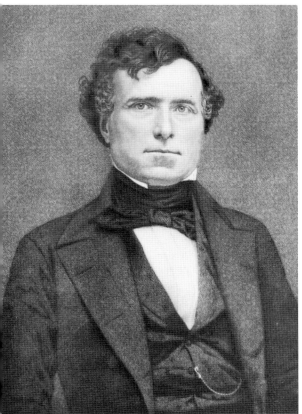

Franklin Pierce
At 48 years old in 1852, Pierce was elected the 14th president of the United States. He is the only chief executive to come from New Hampshire. He was the state's Speaker of the House in 1831, the youngest ever to serve. Pierce was the only state legislator to have served under his father (Benjamin was governor of New Hampshire). Pierce (1804–1869) also served as a US representative from 1833 to 1837 and as a US senator from 1837 to 1842. In 1847, he rose to the rank of brigadier general and fought in the Mexican-American War. He was successful in two battles in Mexico City but was thrown from his horse and injured. Pierce retired to Concord and lived here until his death. (Left, courtesy LOC.)

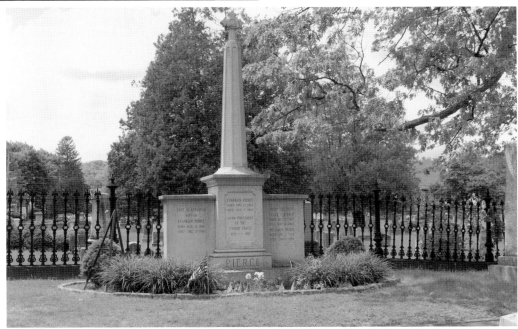

M.T. Menino

In 1993, a small group of people got together to save a historic building scheduled for demolition on South Main Street. The search committee found its first executive director in Menino, and the Capitol Center for the Arts opened in 1994. Menino, larger than life, could both charm and intimidate people with her big laugh and her big heart. She was an advocate for the arts, generating excitement in the community and working with volunteers to make Capitol Center for the Arts a premier destination for the performing arts. On Thanksgiving weekend in 2005, Menino's community voice was prematurely silenced by a heart attack at age 55. (Courtesy Capitol Center for the Arts.)

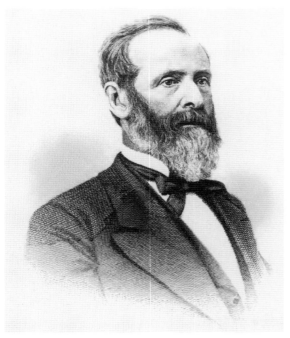

John Kimball, Mayor
Kimball's name was a household word in Concord. Self-educated, he worked for the railroads at a young age. He led a full life of public service in various elected positions, including as a member of the state senate and as mayor of Concord in 1872. He was elected to the city council and served as its president in 1857. Kimball (1821–1912), an engineer by training, was elected to the New Hampshire House for two terms. He is credited with making Concord "distinctly attractive," with many visual improvements throughout the city, including schoolhouses, shade trees, well-maintained roads, and elegant bridges.

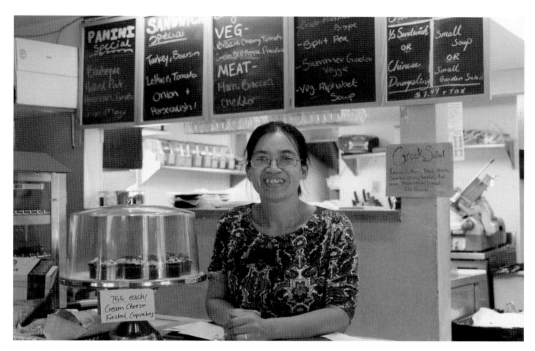

Sandy Schafer, In a Pinch Cafe

Raising four children ages 9 to 18 and running two cafés leaves Sandy Schafer little time for anything else. She purchased the café from longtime owner Paula Stephen after Stephen died of leukemia in 2011, and she continues the café's tradition of delicious sandwiches and soups on the run. Schafer has not changed the menu much, except for adding a few Asian spices to some dishes and experimenting with different soups. Why change the menu when it has been working all these years? Schafer, a native of Taiwan, works 16-hour days, which include cooking, getting the children ready for school, and managing the two locations.

Frank West Rollins, Conservationist

A founder of the Society for the Protection of New Hampshire Forests, Rollins (1860–1915) was the son of Edward H. Rollins. He was the author of several books and established "Old Home Week" in New Hampshire to encourage those who moved away to return to the state. In 1892, he donated a "woodland park of natural growth" to the City of Concord in honor of his father. That site is today named Rollins Park. (Courtesy Society for the Protection of New Hampshire Forests.)

Emma Gannell Rumford Burgum, Countess's Daughter

Burgum (1826–1923), the adopted daughter of the Countess of Rumford, lived in London for 10 years before studying painting under a French master instructor in 1838. She married John Burgum in 1852, then, two months after that, the Countess of Rumford died.

Armenia Aldrich White, Suffragette

Married in 1836 at 19 years of age, Armenia White (1817–1916) was active in women's suffrage and charity work. She and her husband, Nathaniel, lived for some time on Warren Street and then moved to School Street. They were active in many causes and were one of Concord's most prominent couples. Armenia was the first president of the New Hampshire Woman Suffrage Association and organized the first convention in the state, held at the Eagle Hall in 1868. It was because of her that the state legislature in 1871 granted women the right to serve on school committees and, in 1878, the right to vote in school affairs. This preceded any other women in New England securing the right to vote. Together, the Whites erected a house of worship for the Universalist Society of Concord. Armenia was known as "an active and fearless champion of temperance, anti-slavery and other reforms," as discribed in James O. Lyford's *History of Concord*. She outlived her eight children.

Styles Bridges, US Senator (ABOVE AND OPPOSITE PAGE)
Bridges (1898–1961) was devoted to public service and served 24 years in the US Senate and one term as governor. The Bridges House (above) was built by Charles Graham about 1836 and became the governor's official residence in 1969. Bridges lived there from 1946 until his death. The house was officially listed in the National Register of Historic Places in 2005.

Ebenezer Eastman, Early Settler

When Eastman was 19, he served in the infantry in expeditions against Canada and the French. One of Concord's first settlers, in 1726, Eastman came to Concord and began clearing land and building a corn mill and barns. He and his six sons are credited with being the leading spirit in settling the town. Captain Eastman (1681–1748) served as moderator of the first town meeting in 1732 and was a selectman until his death.

Leslie Clark, Environmentalist

Clark was education director for the Society for the Protection of New Hampshire Forests. By all accounts, he did more to advance local and state awareness of environmental issues than any one person had in the past. In 1960, he attended the New England Conservation Conference in support of the grassroots efforts to allow New Hampshire cities and towns to establish a conservation commission. Although the law was passed, it would be five years before the first conservation commission was formed. (Courtesy Society for the Protection of New Hampshire Forests.)

J. Stephen Abbot

Joseph Stephen Abbot was a 22-year-old who apprenticed for eight years in Salem before Lewis Downing recruited him to help build the Concord Coaches. Their business philosophies differed, and they parted ways in 1847. The largest of the coaches transported up to 21 people, 12 passengers inside and the remainder on the roof—definitely not for the faint of heart.

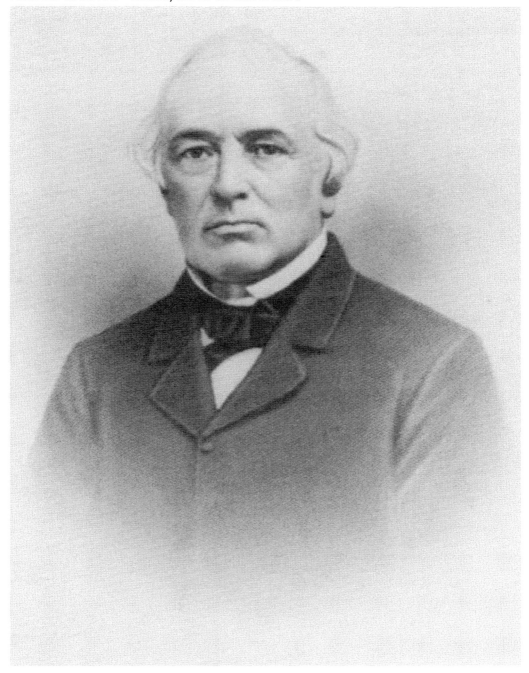

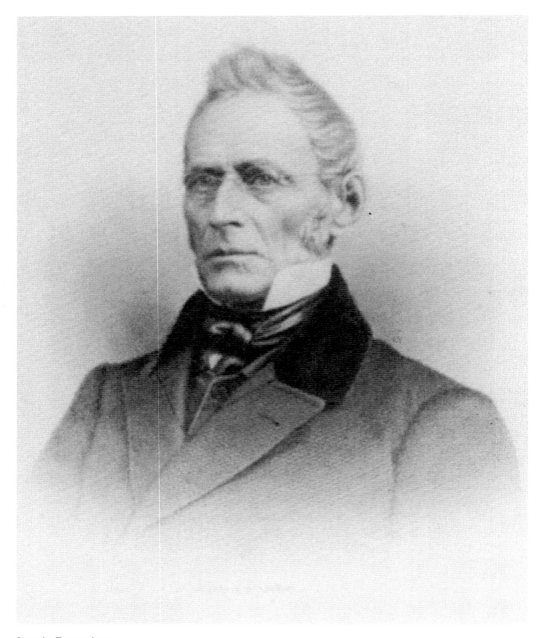

Lewis Downing

A wheelwright by trade, Downing did not know stagecoach body building, so he partnered with J. Stephen Abbot. Married in 1815, his business flourished on the corner of Perley and South Main Streets. During its 100 years in business, Abbot and Downing Company built 40 different types of commercial vehicles. By 1826, the use of thoroughbraces in the suspension made the Concord Coaches a smooth ride for long distances.

INDEX